Remembering
Grand Rapids

Karolee R. Hazlewood

TURNER
PUBLISHING COMPANY

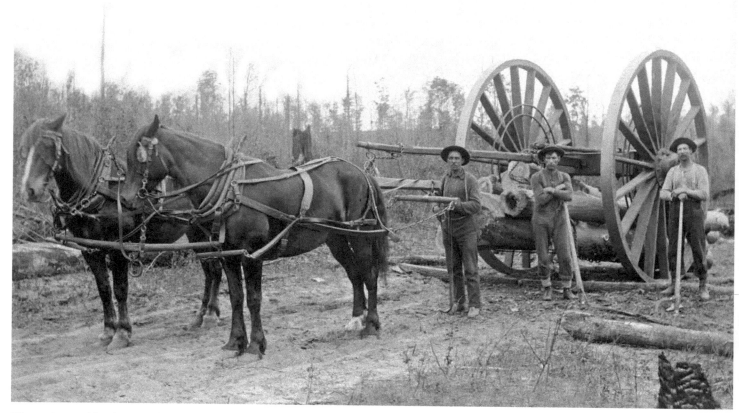

Harvesting and hauling cut logs was once accomplished without the aid of steam-powered or motorized machinery.

Remembering
Grand Rapids

Turner Publishing Company
www.turnerpublishing.com

Remembering Grand Rapids

Copyright © 2010 Turner Publishing Company

All rights reserved.
This book or any part thereof may not be reproduced or transmitted
in any form or by any means, electronic or mechanical, including
photocopying, recording, or by any information storage and retrieval
system, without permission in writing from the publisher.

Library of Congress Control Number: 2010932277

ISBN: 978-1-59652-704-1

Printed in the United States of America

ISBN: 978-1-68336-834-2 (pbk.)

CONTENTS

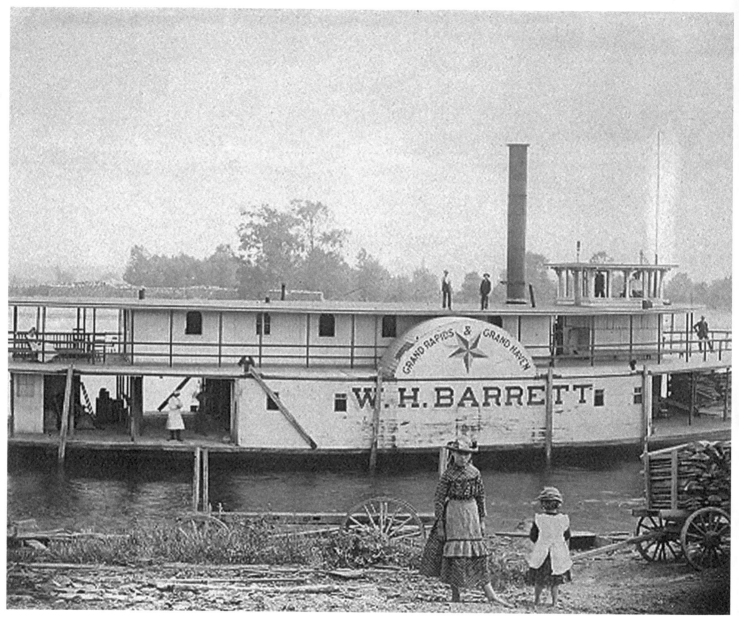

The wood-fueled steamer, W. H. Barrett, ran between Grand Rapids and Grand Haven on the Grand River. Steamboat Barrett was built in 1874 and ran until 1894. It was designed and built by John Muir for the Ganoe Company.

Acknowledgments

This volume, *Remembering Grand Rapids,* is the result of the cooperation and efforts of many individuals and organizations. It is with great thanks that we acknowledge the valuable contribution of the Grand Rapids History and Special Collections Department of the Grand Rapids Public Library for their generous support.

PREFACE

Grand Rapids has thousands of historic photographs that reside in archives, both locally and nationally. This book began with the observation that, while those photographs are of great interest to many, they are not easily accessible. During a time when Grand Rapids is looking ahead and evaluating its future course, many people are asking, How do we treat the past? These decisions affect every aspect of the city—architecture, public spaces, commerce, infrastructure—and these, in turn, affect the way that people live their lives. This book seeks to provide easy access to a valuable, objective look into the history of this great city.

The power of photographs is that they are less subjective than words in their treatment of history. Although the photographer can make subjective decisions regarding subject matter and how to capture and present it, photographs seldom interpret the past to the extent textual histories can. For this reason, photography is uniquely positioned to offer an original, untainted look at the past, allowing the viewer to learn for himself what the world was like a century or more ago.

This project represents countless hours of review and research. The researchers and writer have reviewed thousands of photographs in numerous archives. We greatly appreciate the generous assistance of the organizations listed in the acknowledgments of this work, without whom this project could not have been completed.

The goal in publishing this work is to provide broader access to this set of extraordinary photographs that seek to inspire, provide perspective, and evoke insight that might assist people who are responsible for determining the future of Grand Rapids. In addition, the book seeks to preserve the past with adequate respect and reverence.

With the exception of touching up imperfections that have accrued with the passage of time and cropping where necessary, no changes have been made. The focus and clarity of many images is limited to the technology and the ability of the photographer at the time they were taken.

The work is divided into eras. Beginning with some of the earliest-known photographs of Grand Rapids, the first section records photographs through the end of the nineteenth century. The second section spans the beginning of the twentieth century through World War I. Section Three moves through the era between the great wars, and the last section covers the World War II era and the early postwar years.

In each of these sections we have made an effort to capture various aspects of life through our selection of photographs. People, commerce, transportation, infrastructure, religious institutions, and educational institutions have been included to provide a broad perspective.

We encourage readers to reflect as they go walking in Grand Rapids, strolling through the city, its parks, and its neighborhoods. It is the publisher's hope that in utilizing this work, longtime residents will learn something new and that new residents will gain a perspective on where the city has been, so that each can contribute to its future.

—*Todd Bottorff, Publisher*

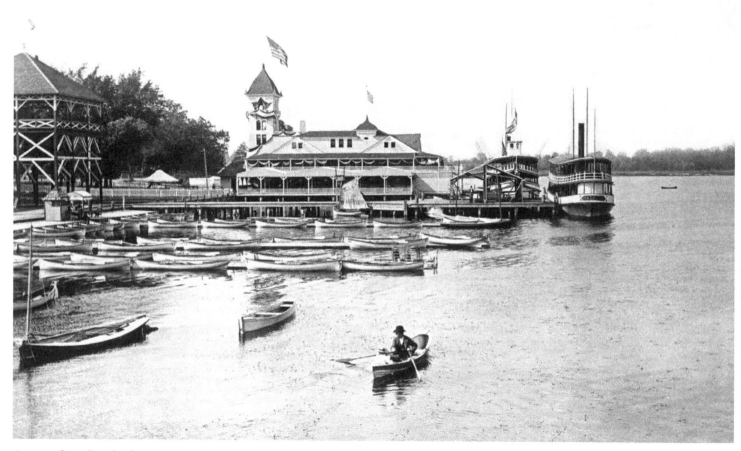

A view of Reed's Lake facing north.

THE BIRTH OF A CITY

(1870s–1899)

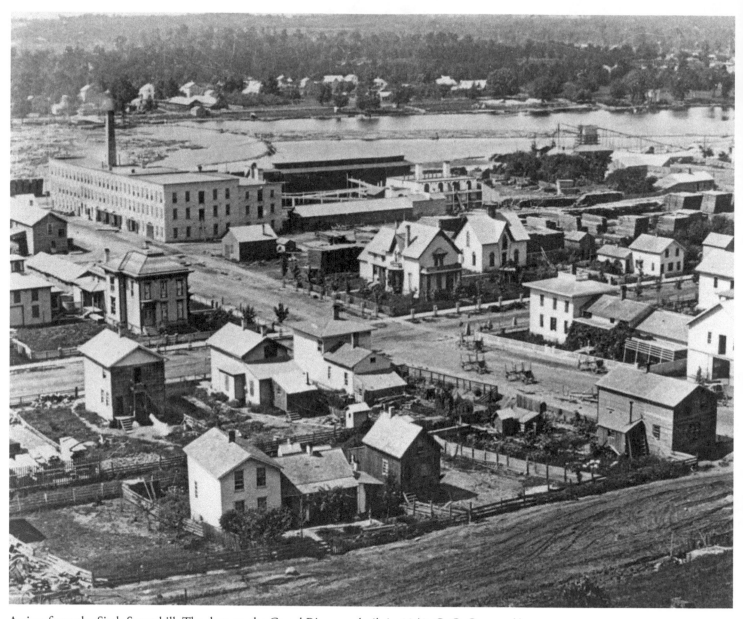

A view from the Sixth Street hill. The dam on the Grand River was built in 1849. C. C. Comstock's Tub and Pail Company is on the left. The Sixth Street bridge has not yet been built.

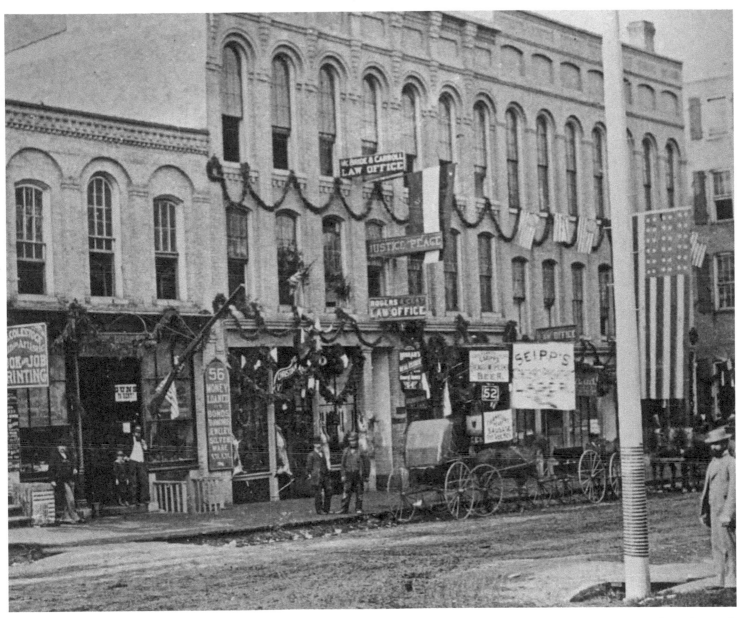

Lyon Street in 1876.

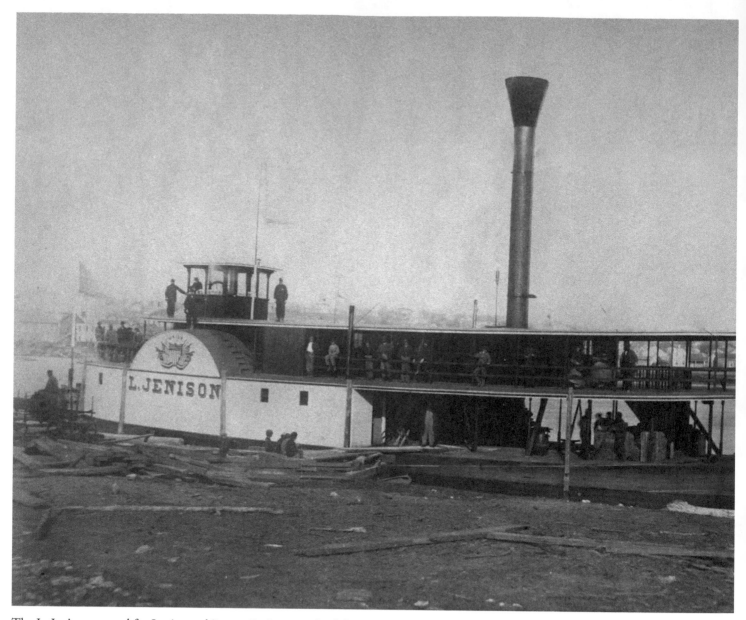

The L. Jenison, named for Lucius and Lyman Jenison, was built by Ganoe and Byron Ball in 1867. It ran up and down the Grand River for eight years. Like many steamboats, it perished in a fire.

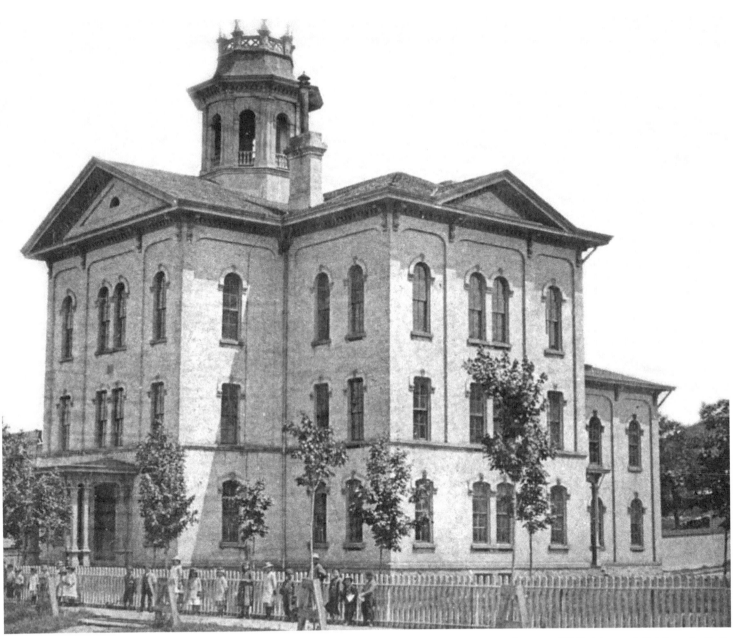

The North Ionia School was located on North Ionia Street between Walbridge and Coldbrook. Built in 1871 with room for 600 students, this was one of the original schools to become part of the city school system when it was organized that same year.

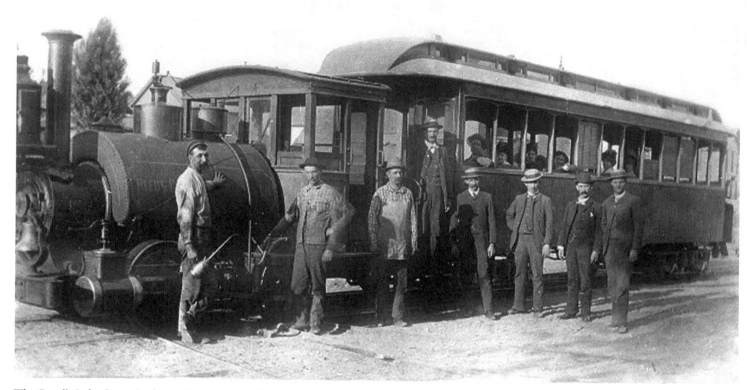

The Reed's Lake Street Railway Company ran from Sherman Street and Eastern Avenue, heading east on Sherman to Reed's Lake.

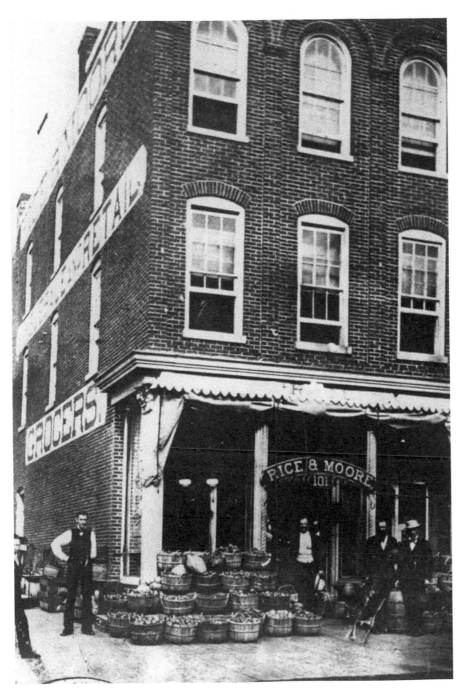

The first Police Headquarters was located on the second floor of Rice and Moore's Grocery on the southeast corner of Monroe and Ionia from 1871 to 1882, when the headquarters was moved to a larger facility on the corner of Lyon and Campau streets.

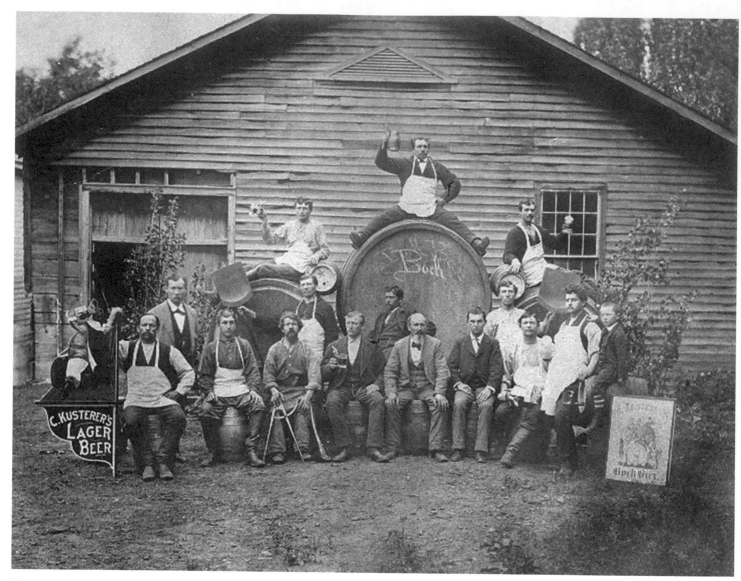

The northeast corner of Michigan Street and Ottawa Avenue was the home of C. Kusterer's Lager Beer and Kusterer's Cooper Shop. Employees pictured are (front row) Vincent Fox, Frank Wagner, George Koch, Adolph Goetz, Chris Kusterer, Chris Kusterer, Jr., Charles Merkle, Ed. Wagner, and Kid Kusterer. In the second row are an unidentified person, Adam Herl, Chris Wagner, and Aug. Kusterer. In the third row are John Hubel and another unidentified person. Seated atop the large keg is Ada Alberts.

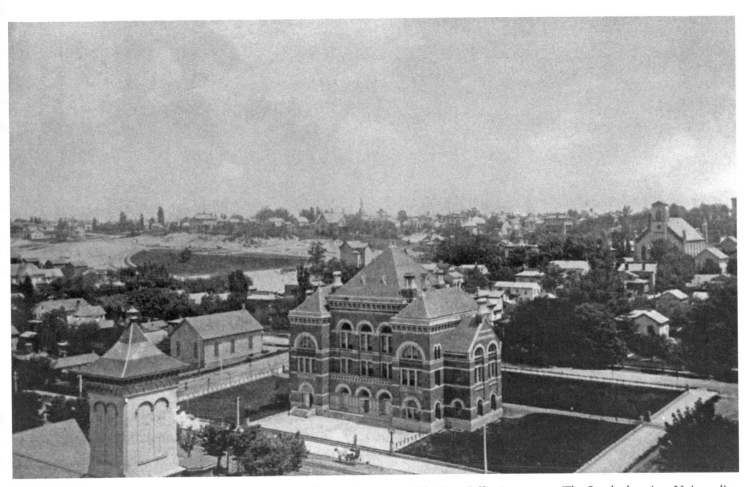

Downtown as it was beginning to grow. The Post Office is at center. The Swedenborgian, Universalist, and Second Reformed churches are visible, along with the old high school.

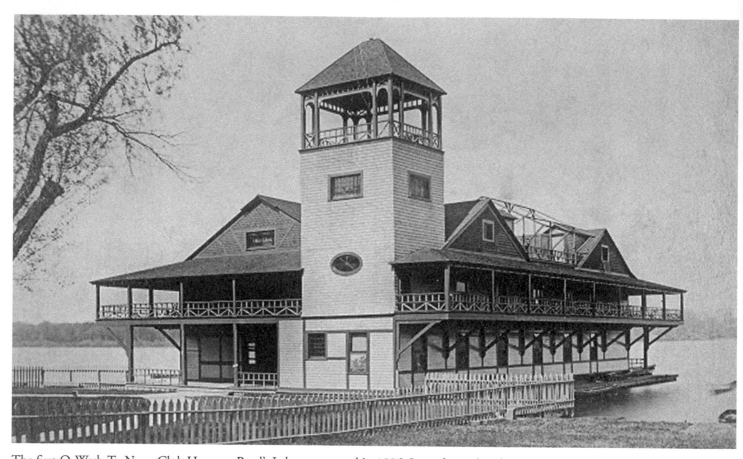

The first O-Wash-Ta-Nong Club House at Reed's Lake was erected in 1886. It was located at the north end of what is now John Collins Park.

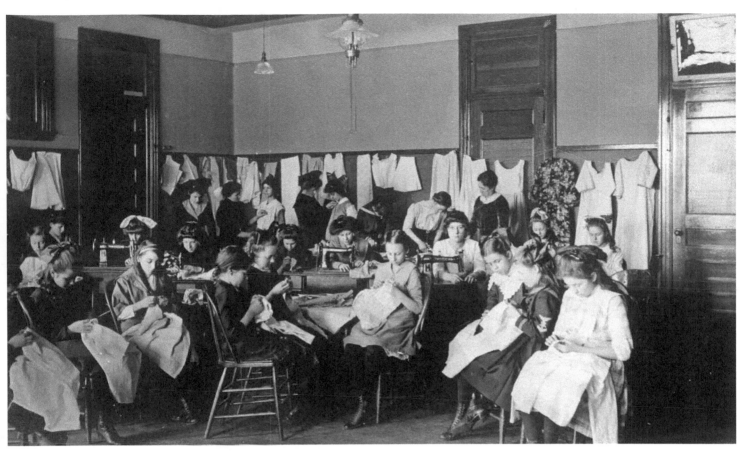

A sewing class at East Bridge Street School.

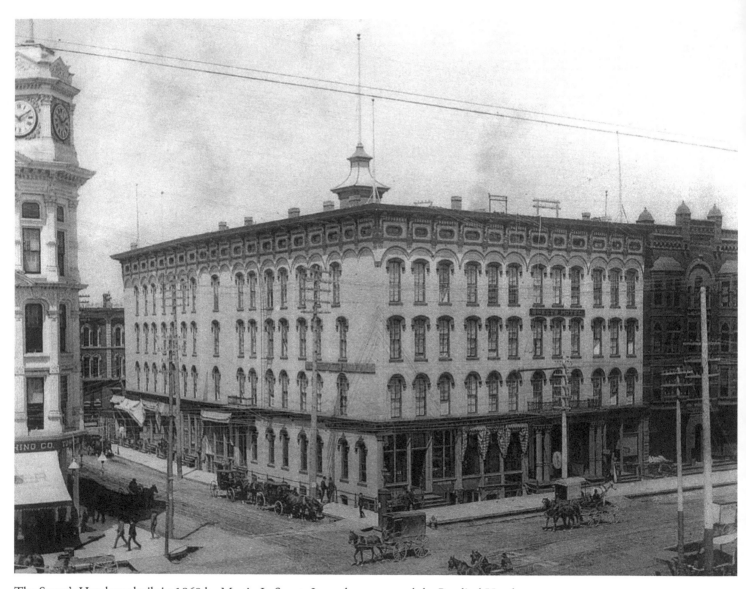

The Sweet's Hotel was built in 1868 by Martin L. Sweet. It was later renamed the Pantlind Hotel after J. Boyd Pantlind took over in 1902. It is currently part of the Amway Grand Plaza Hotel.

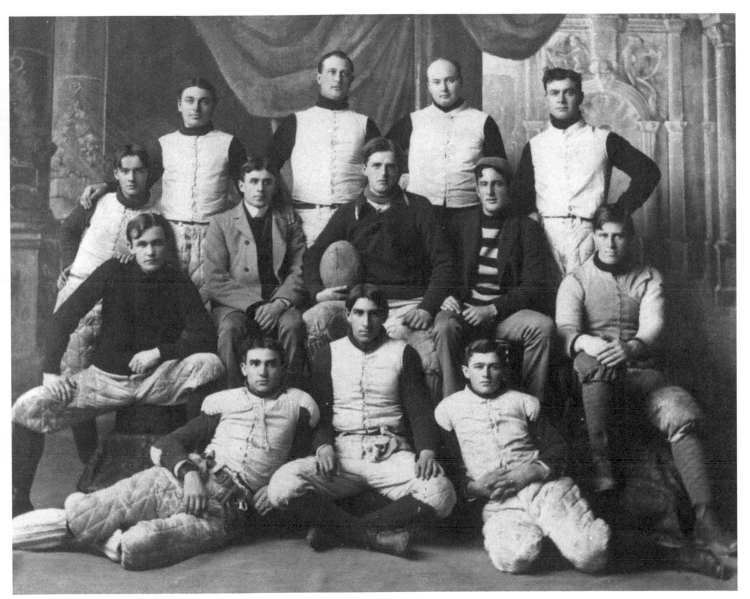

A local football team takes time out to pose for a group portrait.

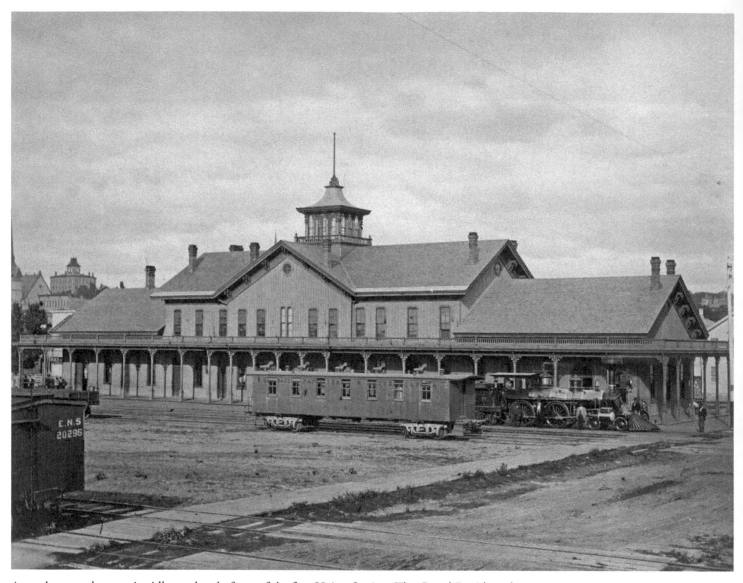

An early steam locomotive idles at the platform of the first Union Station. The Grand Rapids and Indiana Railroad ran to Kalamazoo and other cities to the south.

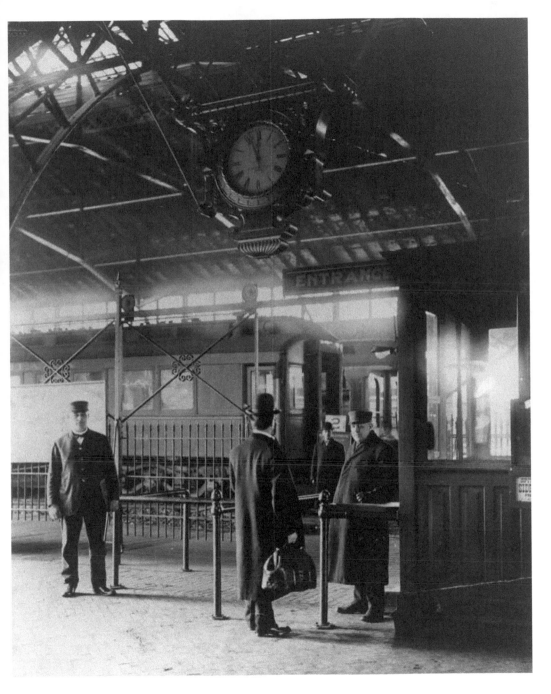

Catching the noon train at Union Depot. This image reveals the wood and iron spans of the train shed from track level. Engineers of the era competed to span ever-greater widths using single-gable arch designs.

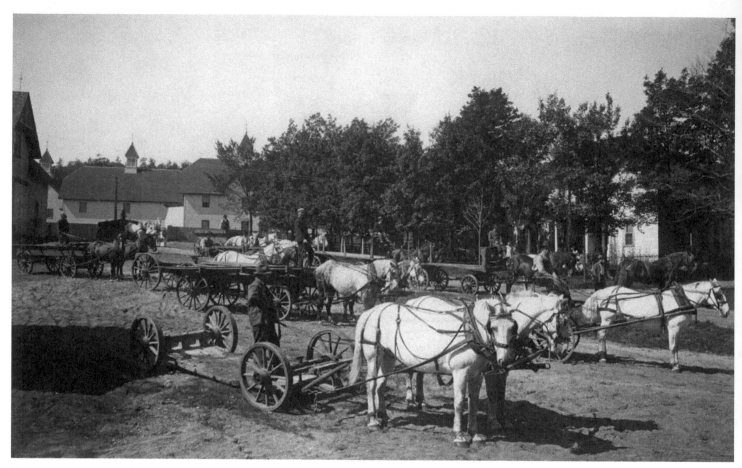

Teams pulling wagons leave for the fields and work.

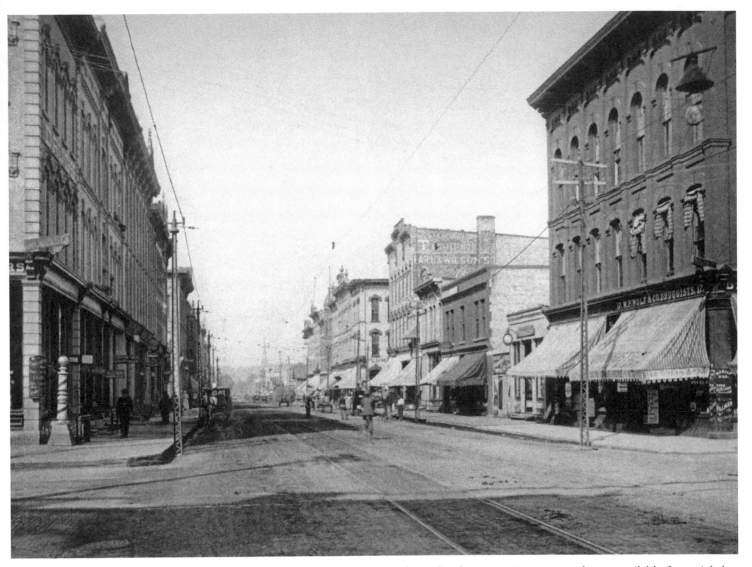

A view of West Bridge Street at Scribner. On the corner, ice cream sodas are available for a nickel at the W. P. Wolf drugstore, which advertises that it is open all night.

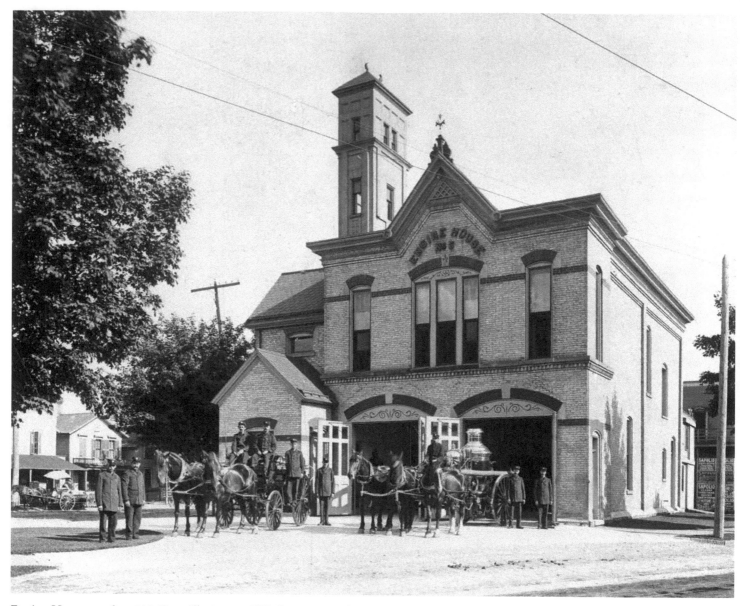

Engine House no. 6, at 312 Granville Avenue SW. Construction began in 1877 and the building was in service by 1879. This is the oldest building in Michigan still extant that was once used as a fire station.

Dawn of a New Century

(1900–1919)

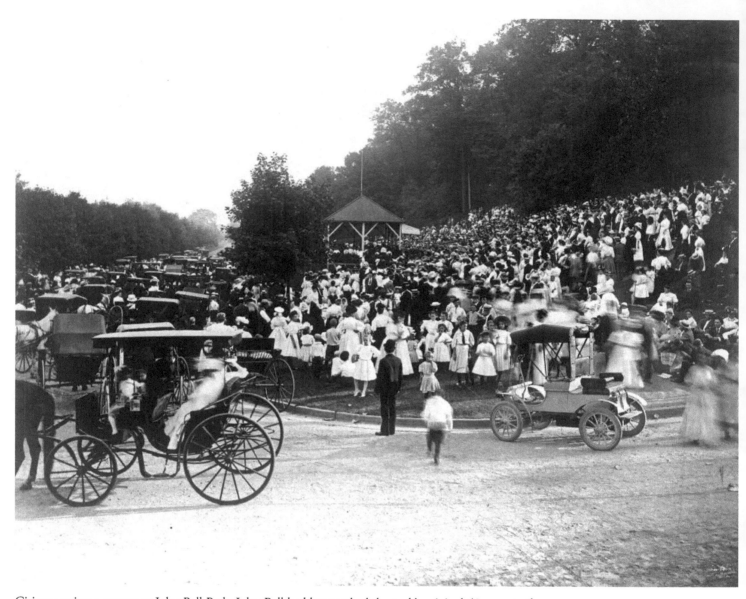

Citizens enjoy a concert at John Ball Park. John Ball had bequeathed the park's original 40 acres to the city in 1884. The park's zoo began in 1891 with a pair of rabbits.

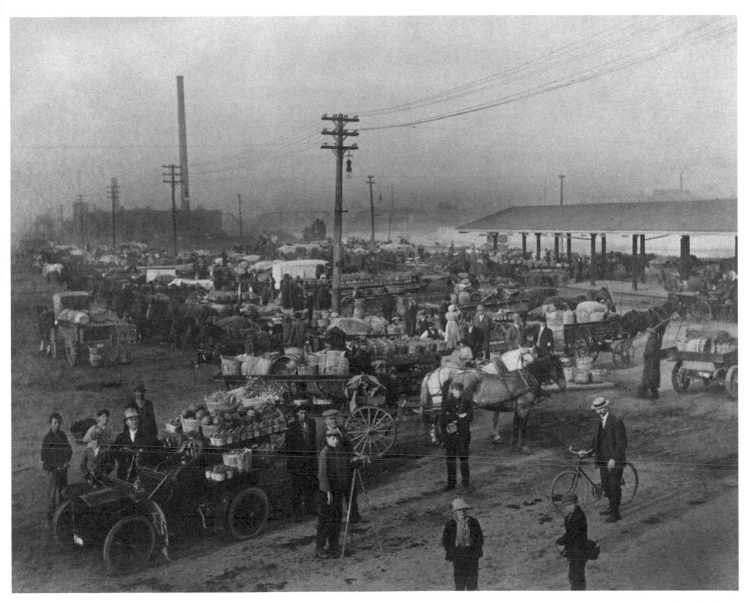

Farmers sell their wares at one of the city's markets. This one was located on Island Park. Wholesale markets like this one served the many grocery stores that existed in those days.

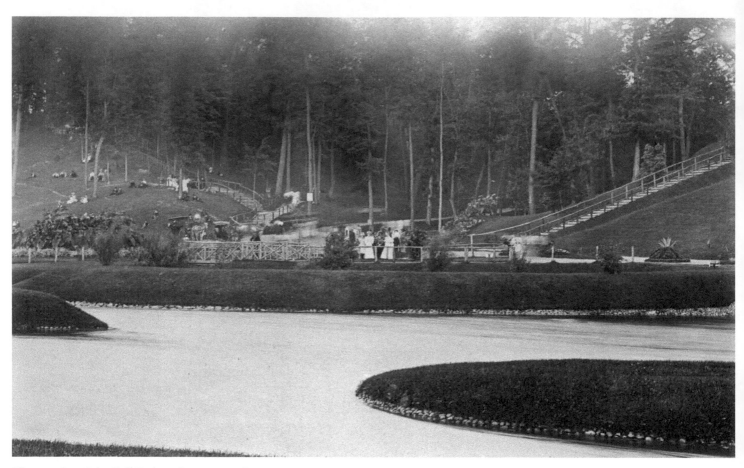

The ponds at John Ball Park as they appeared a century ago.

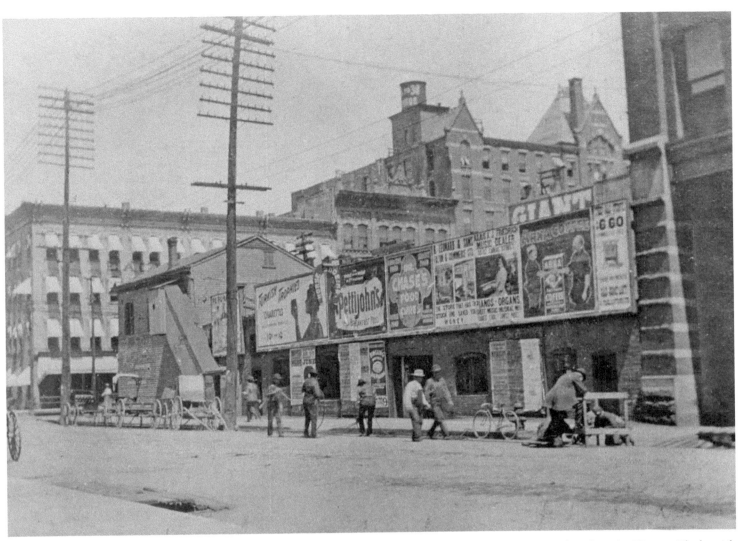

Advertisements abound along Louis Street. Tucked away among the ads is the Hooper Blacksmith Shop.

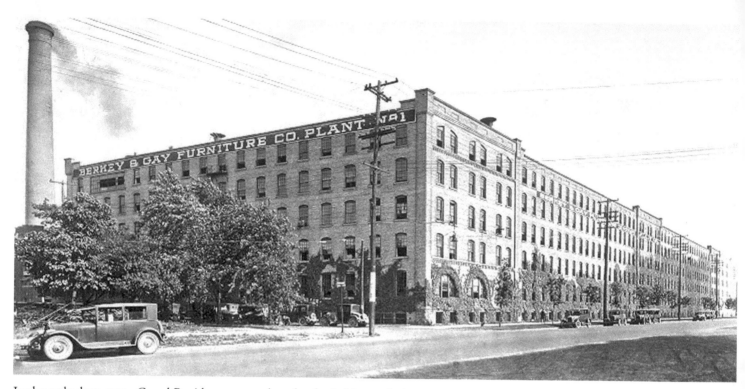

In the early days, many Grand Rapids area men chose lumberjacking as their occupation.

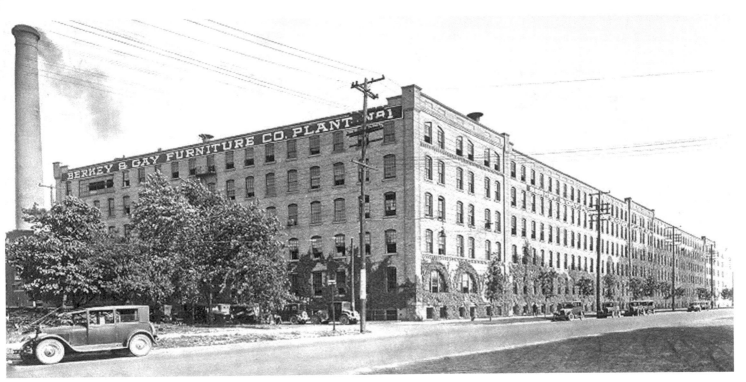

One of Grand Rapids' great furniture plants. Berkey & Gay Furniture Company Plant no. 1 was located on North Monroe.

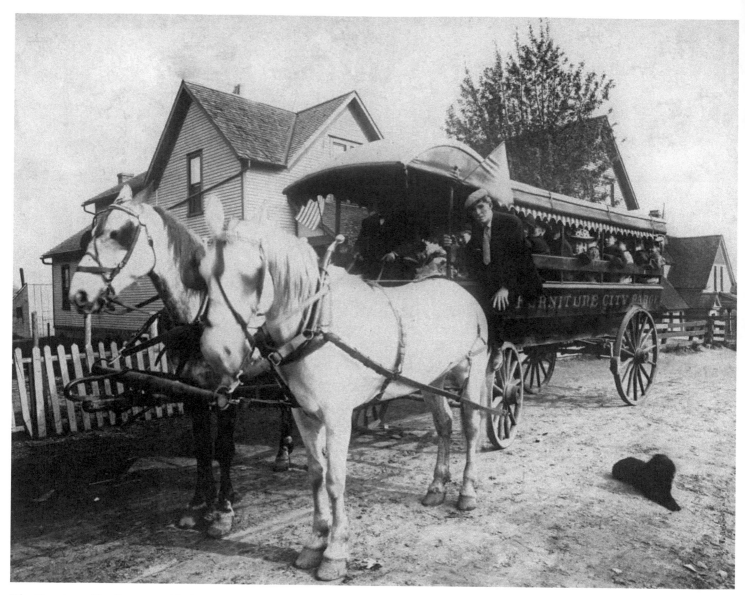

The Furniture City Barge provided transportation throughout the city.

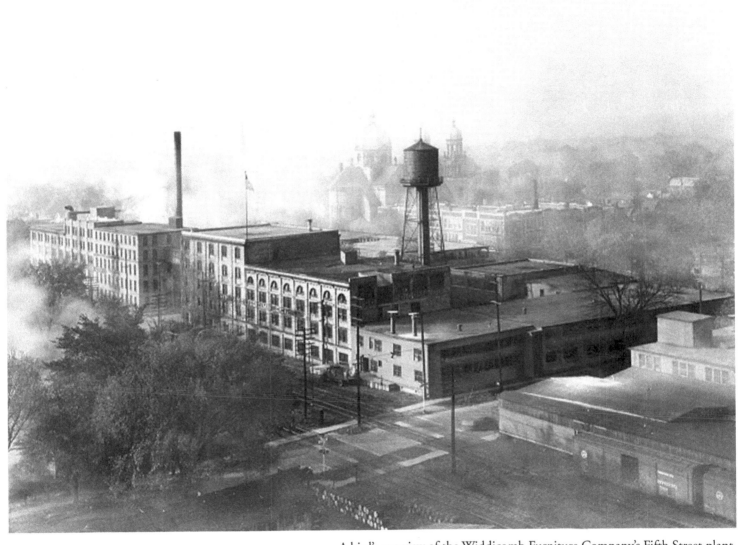

A bird's-eye view of the Widdicomb Furniture Company's Fifth Street plant.

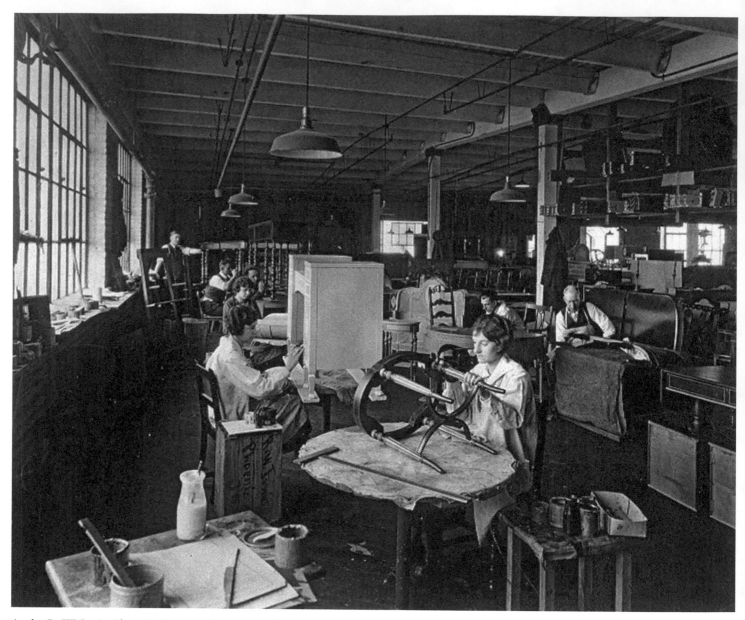

At the R. W. Irwin-Phoenix Furniture factory, employees put the finishing touches on furnishings ranging from dining-room tables to bedroom dressers.

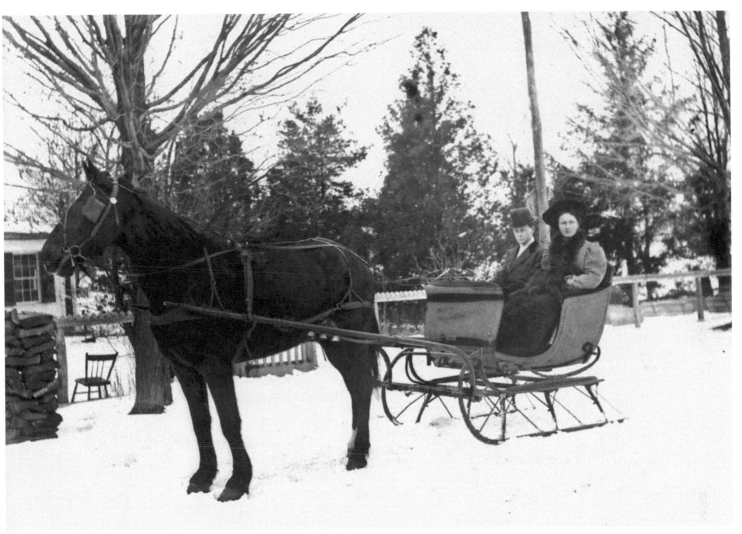

An area couple enjoys a winter sleigh ride.

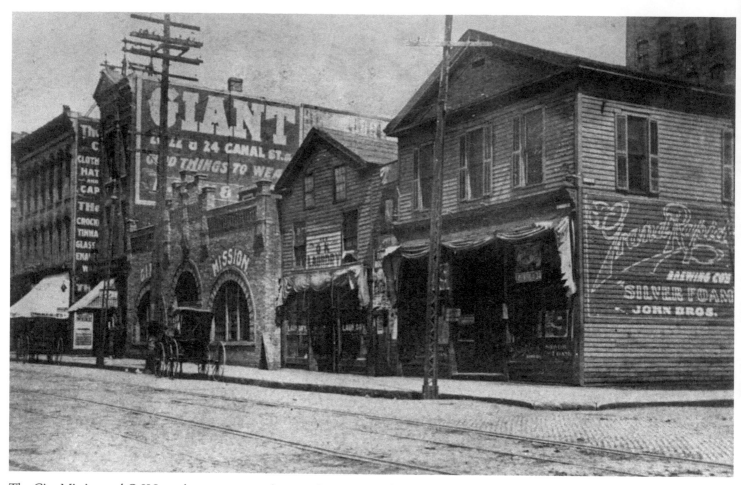

The City Mission and O K Laundry were among the many businesses at the corner of Market and Louis streets.

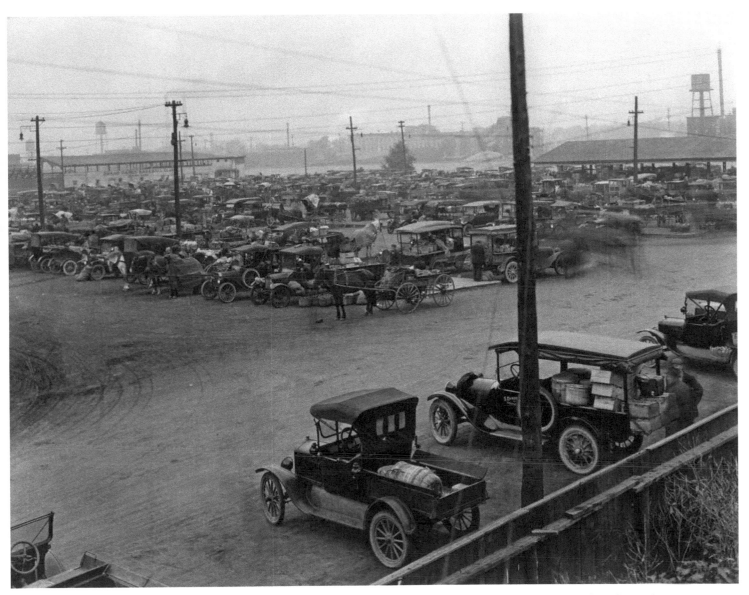

City Farm Market was located at Island Park. With the transition from horse-drawn wagons to motorized vehicles, the number of loads brought to market was on the increase. The Island Park baseball stadium is visible in the background.

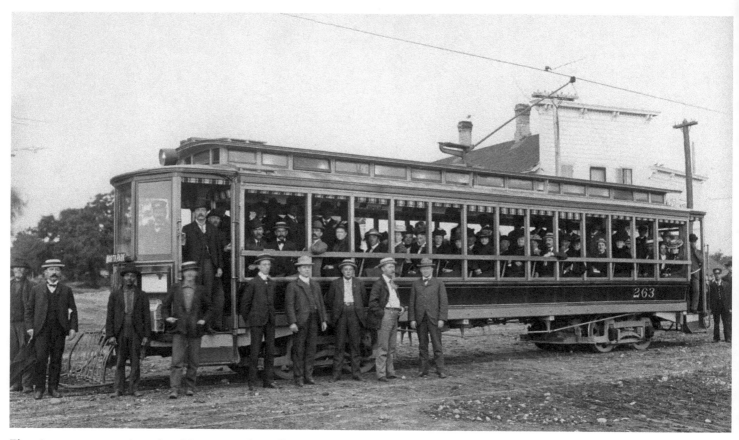

Electric streetcars were introduced in 1891 and rapidly replaced horse-drawn trolleys and cable cars.

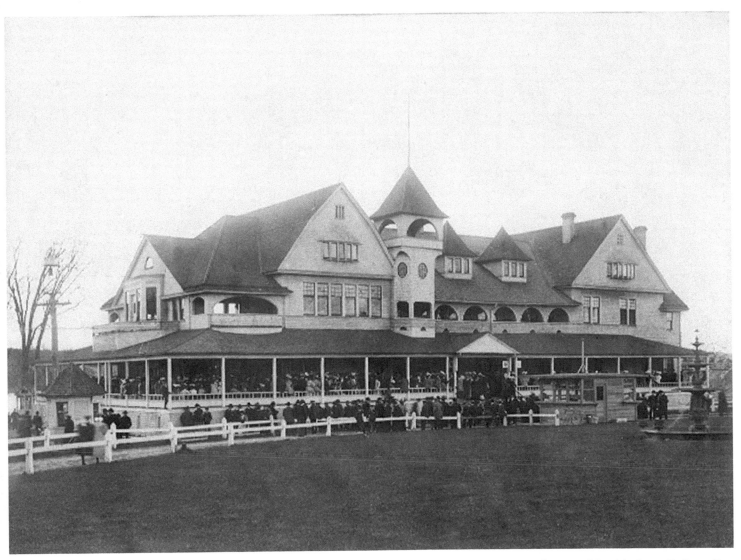

North Park Pavilion, north of the city limits on the Grand Rapids Street Railway line.

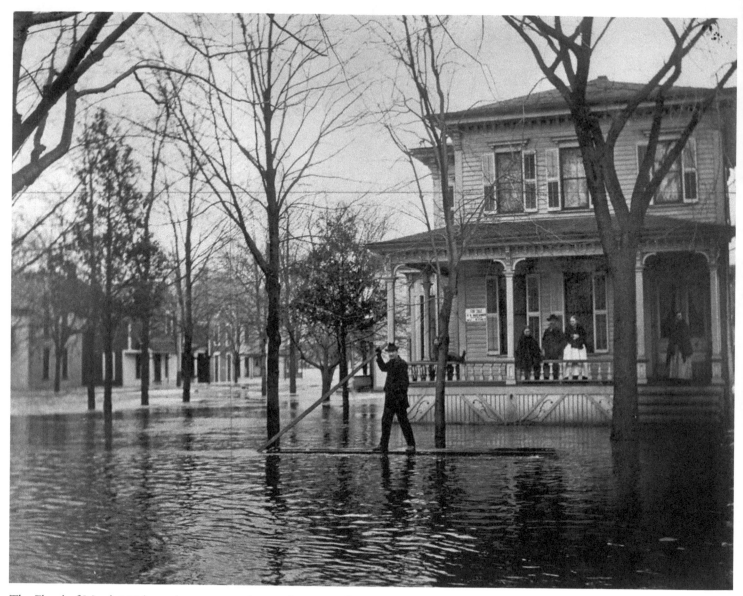

The Flood of March 1904 was the greatest and most destructive flood ever experienced in Grand Rapids. More than half the populated area on the west side of the Grand River was underwater. This view reveals the situation on Fourth Street between Turner and Broadway avenues.

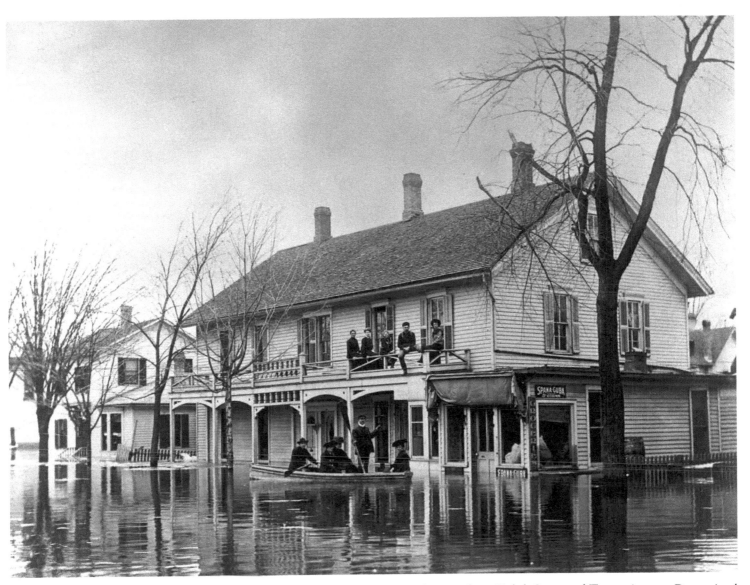

This view of the Flood of 1904 captures the area along Eighth Street and Turner Avenue. Determined not to let the rising waters dismay her spirit, the woman at porchtop center smiles for the camera.

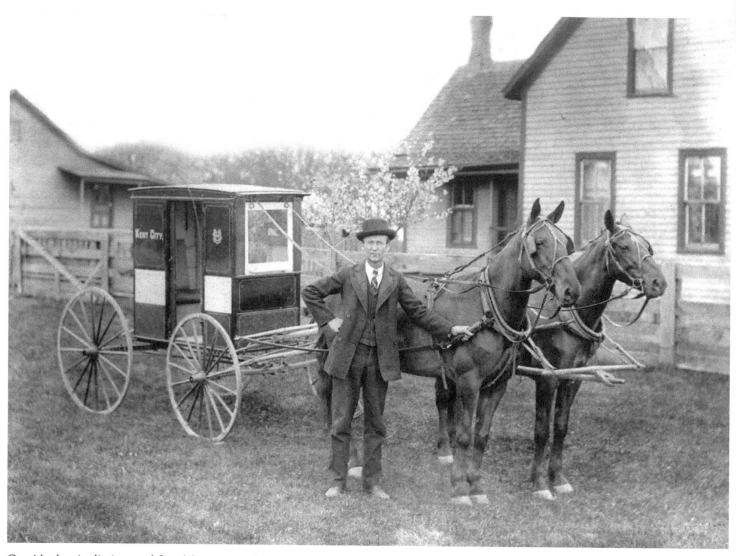

Outside the city limits, rural free delivery started as an experiment in 1886 and became official in 1902. This mail carrier from Kent City poses with his horses and buggy.

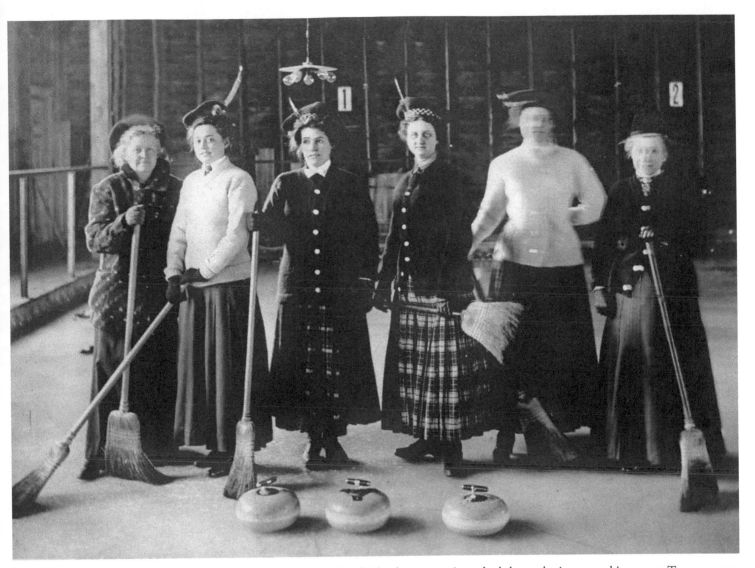

Curling is a team sport in which a large stone is pushed down the ice toward its target. Two sweepers with brooms accompanied each stone to help direct it to its target. In 1908, Grand Rapids was home to the first curling club composed entirely of women. From left to right are Mrs. John Brower, Miss Helen Barstow, Mrs. F. E. Hill, Mrs. Stuart Foote, Miss Rosetta Leitelt, and Mrs. H. B. Snyder.

The soda fountain at West's Drug Store, located at 8-10 Canal, which is today 184-186 Monroe, opposite the Pantlind Hotel. Doesn't that Pineapple Ice sound good?

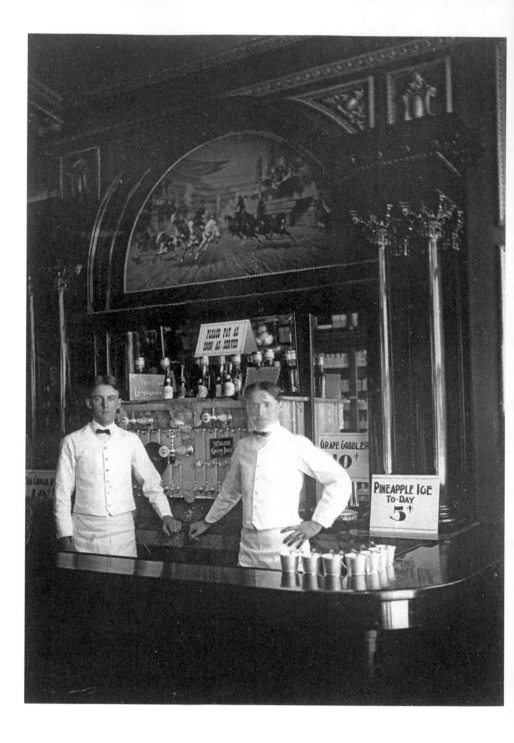

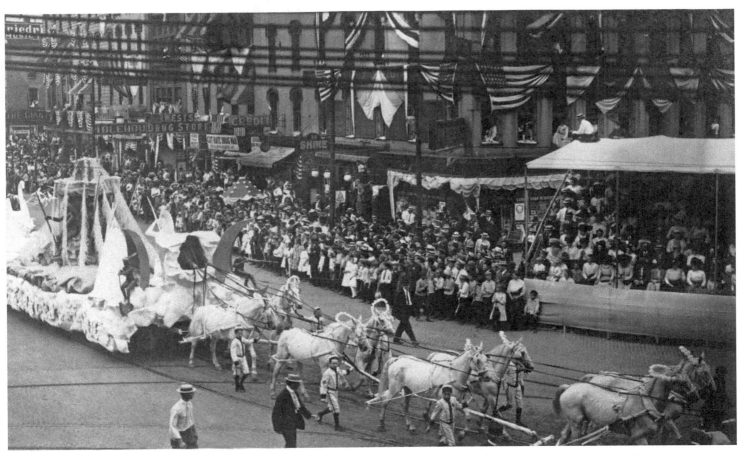

A horse-drawn float in the 1910 Homecoming Celebration parade.

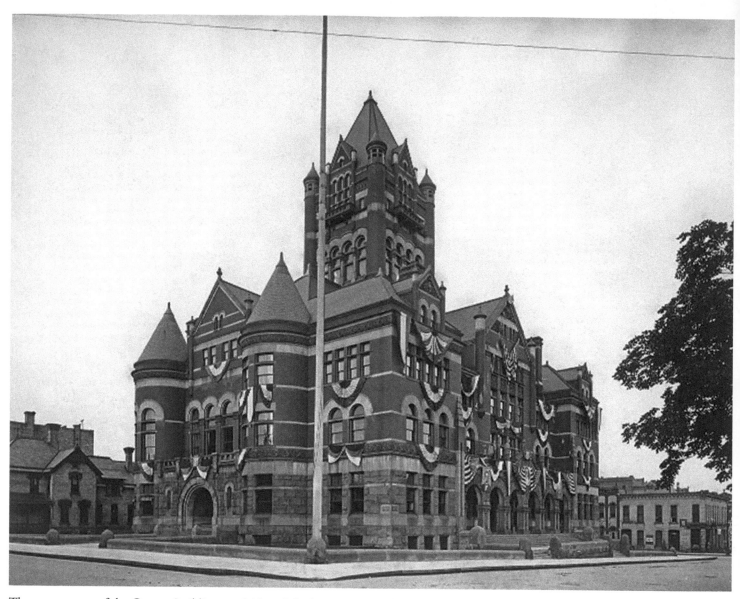

The cornerstone of the County Building was laid on July 4, 1889. Located on the corner of Ottawa Avenue and Crescent Street, it was razed during the urban renewal movement of the 1960s.

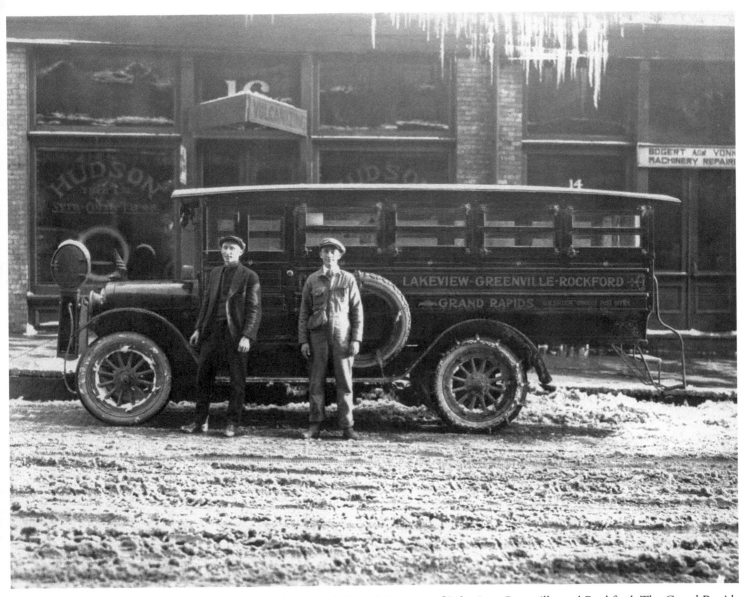

This bus line served the outlying areas of Lakeview, Greenville, and Rockford. The Grand Rapids station was located opposite the post office.

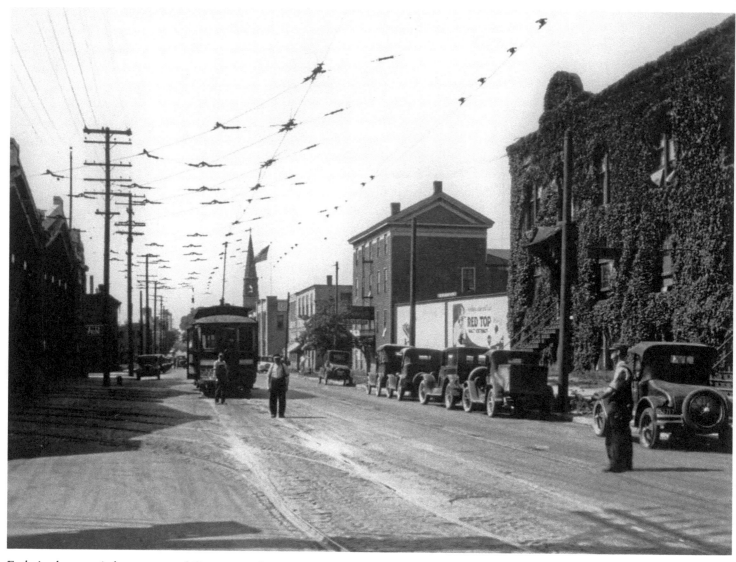

Early in the twentieth century, mobility was on the increase. Both streetcars and automobiles are seen plying the streets of Grand Rapids in this image.

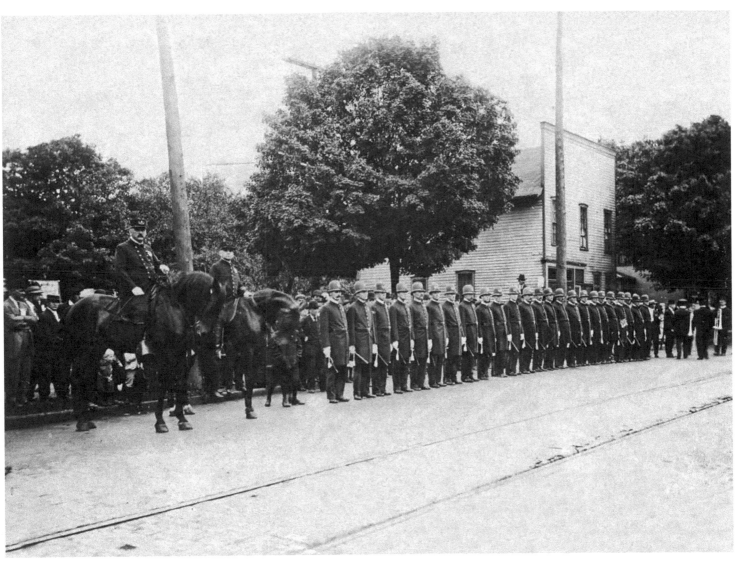

The Grand Rapids Police Department lines up in 1910.

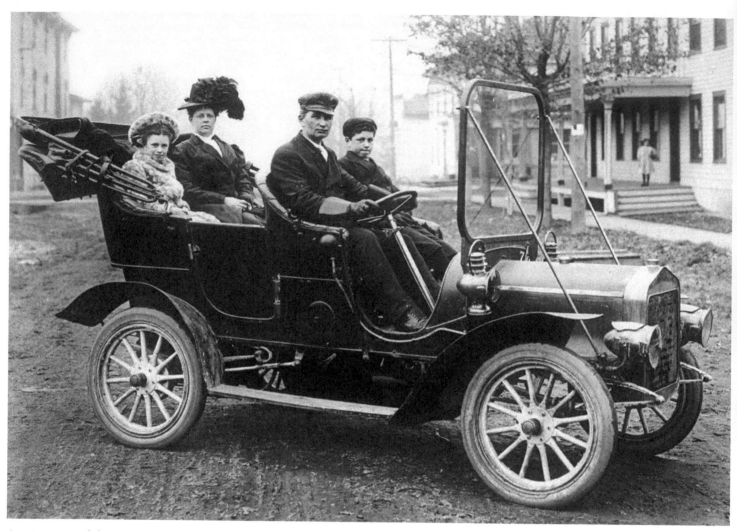

Austin Automobile Company was in business from 1901 to 1921. The company was founded by
James and Walter Austin. They built large, expensive touring cars like the one seen here.

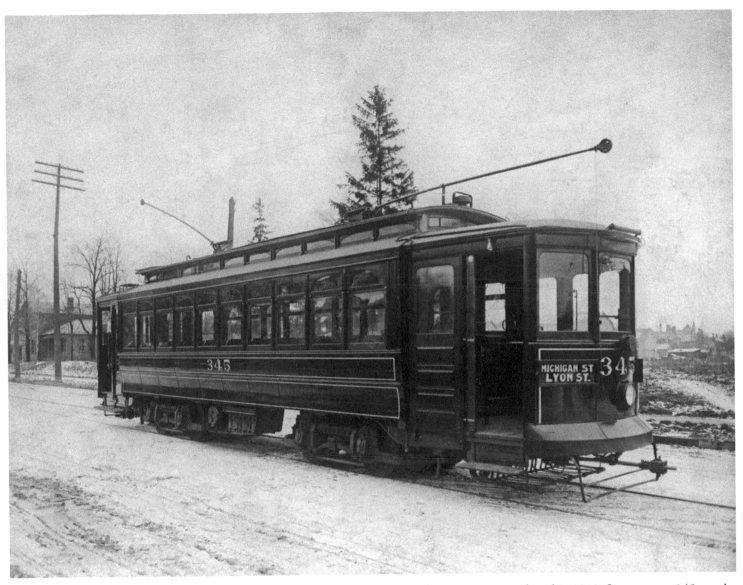

Pictured on a snowy day is one of ten streetcars purchased in 1912. Streetcar no. 345 ran the Michigan-Lyon streets route.

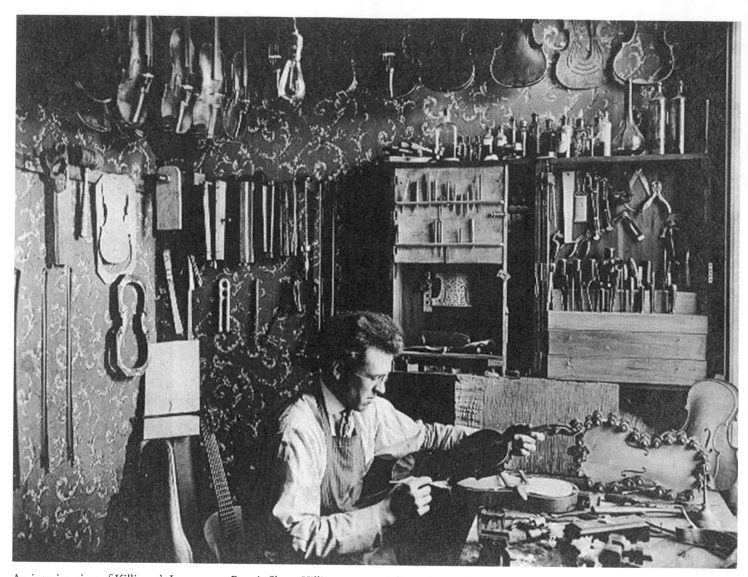

An interior view of Killinger's Instrument Repair Shop. Killinger was a violin maker and repaired all kinds of stringed instruments.

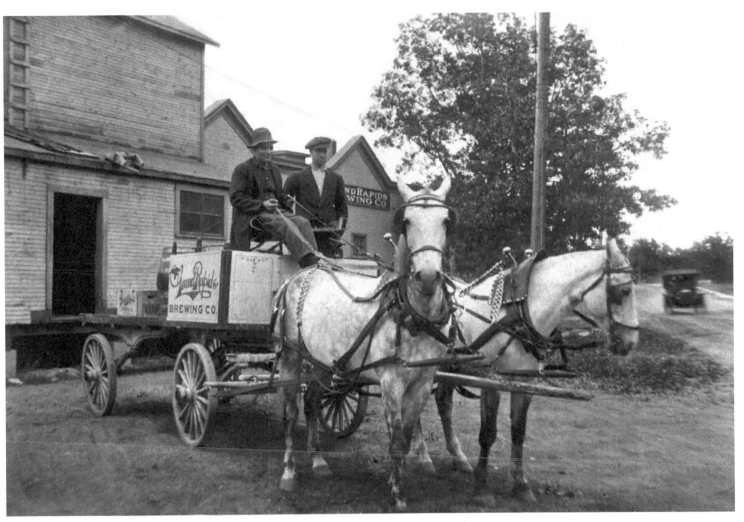

Making a delivery of Silver Foam beer, for which the Grand Rapids Brewing Company was known.

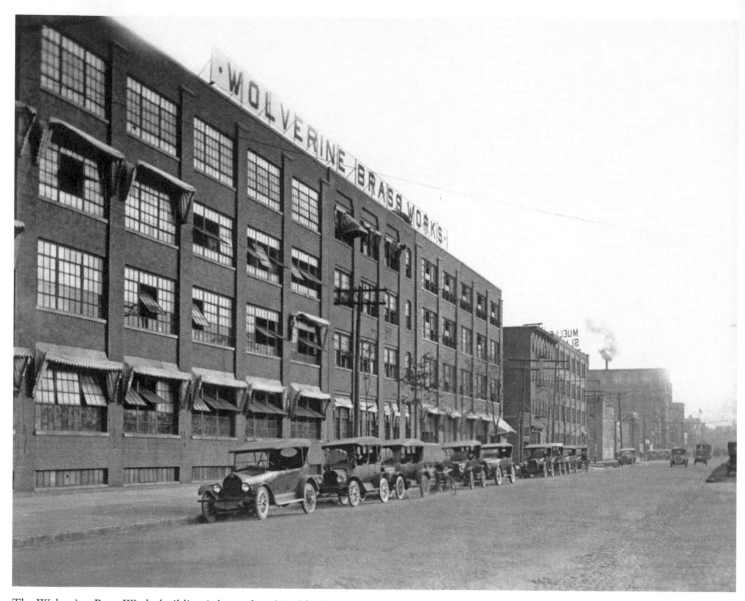

The Wolverine Brass Works building is located at 620-648 Monroe Avenue NW. The company was founded in 1896 by L. A. Cornelius. Its first product was a brass clamp designed to hold a porcelain basin to a lavatory top.

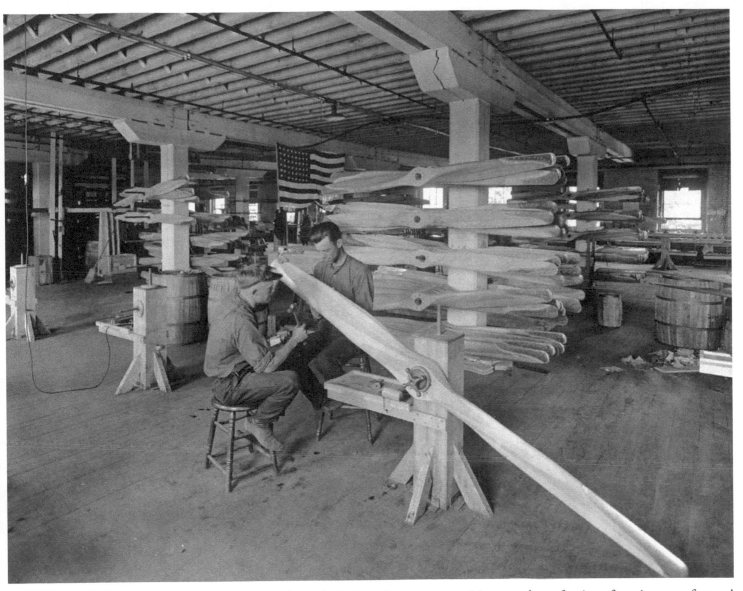

The Grand Rapids Airplane Company, comprising several area furniture factories, manufactured wooden airplane propellers during World War I for the war effort. These men are putting metal tips on the propellers at the Phoenix Furniture Company.

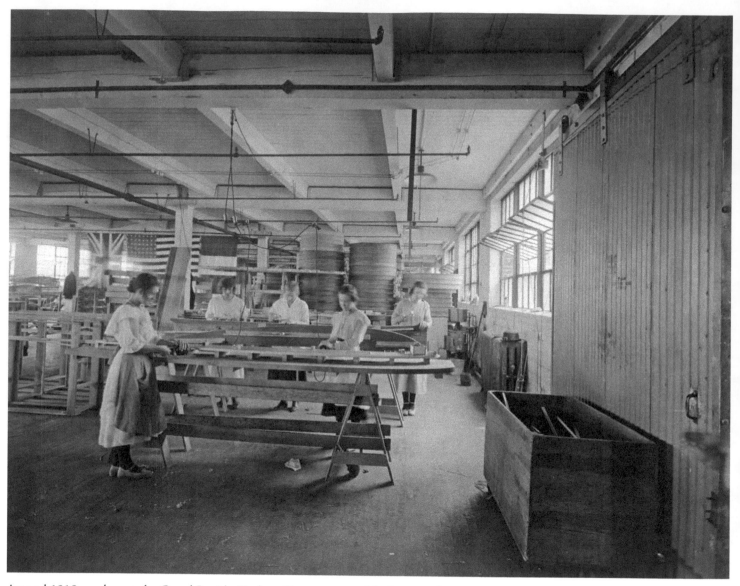

Around 1918, workers at the Grand Rapids Airplane Company assemble the parts that will become aircraft for the war effort.

Between the Wars

(1920–1939)

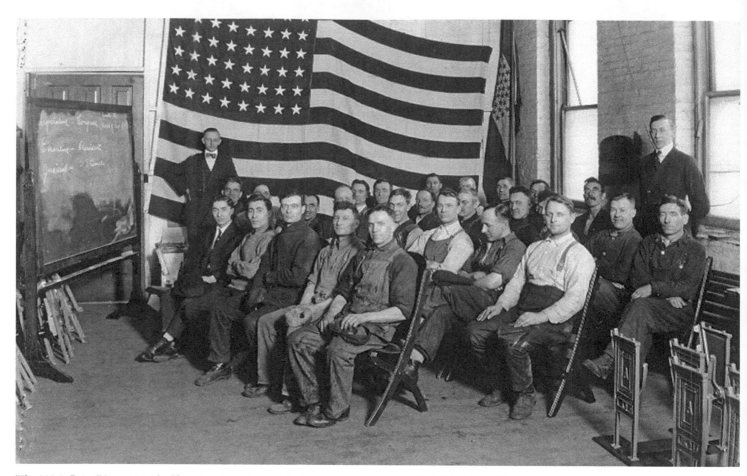

The Y.M.C.A. (Young Men's Christian Association) Industrial Services regularly held citizenship classes like this one at American Seating Company.

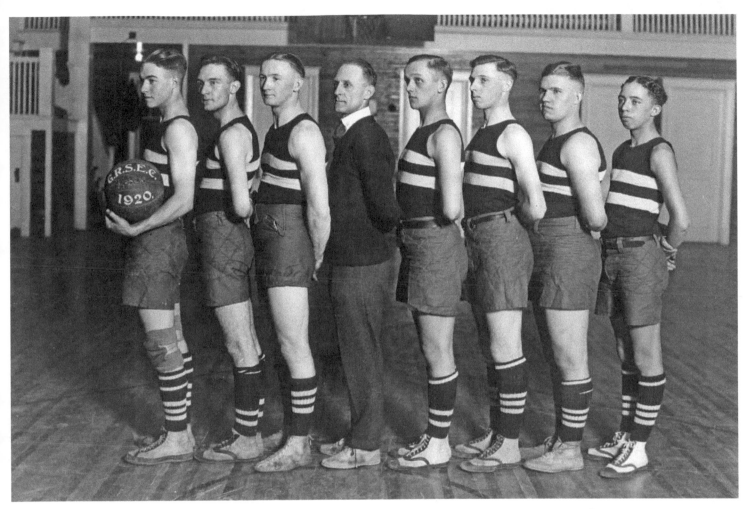

The Grand Rapids School Equipment Company basketball team poses for a group portrait in 1920. Company teams were organized by the Y.M.C.A. Industrial Services.

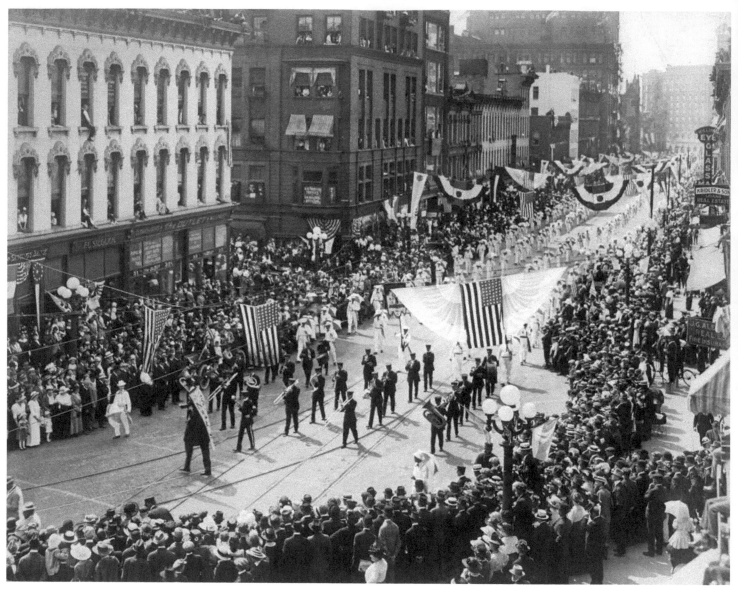

People love a parade. The Benevolent and Protective Order of Elks parade was attended by thousands.

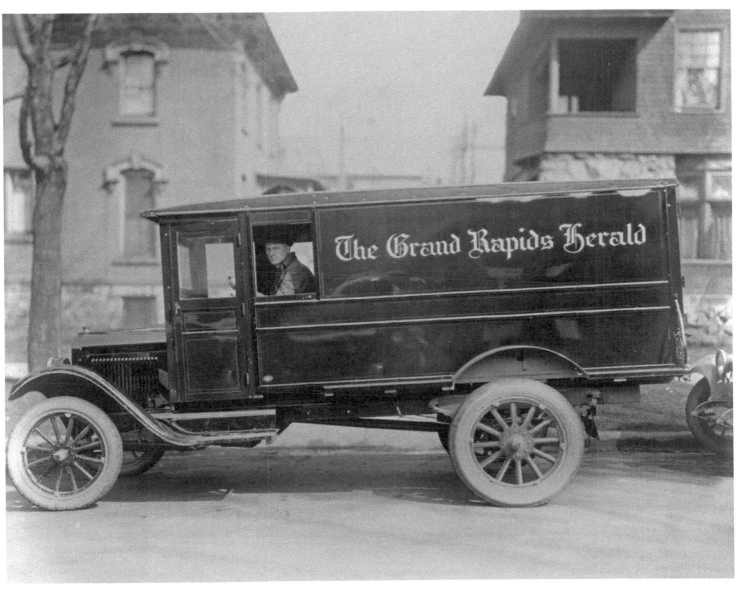

A Grand Rapids Herald delivery truck. The newspaper was in operation from 1892 to 1959.

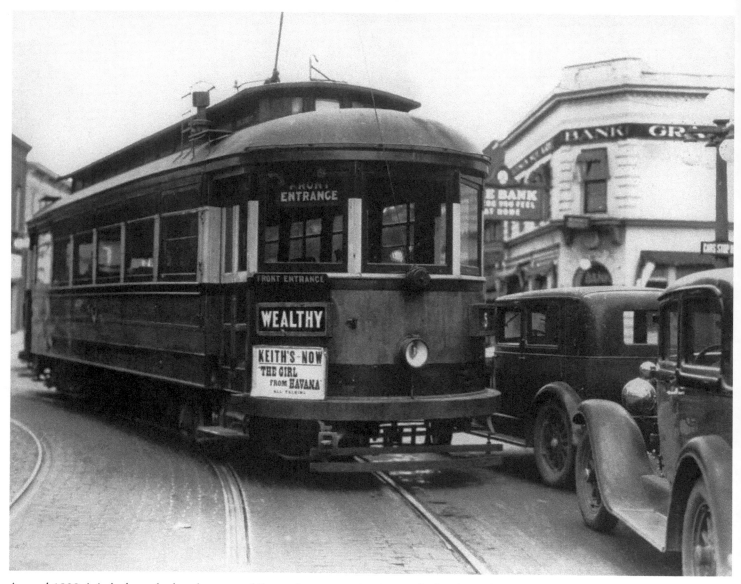

Around 1929, it isn't clear whether the automobiles or the streetcar is winning the battle on this crowded street.

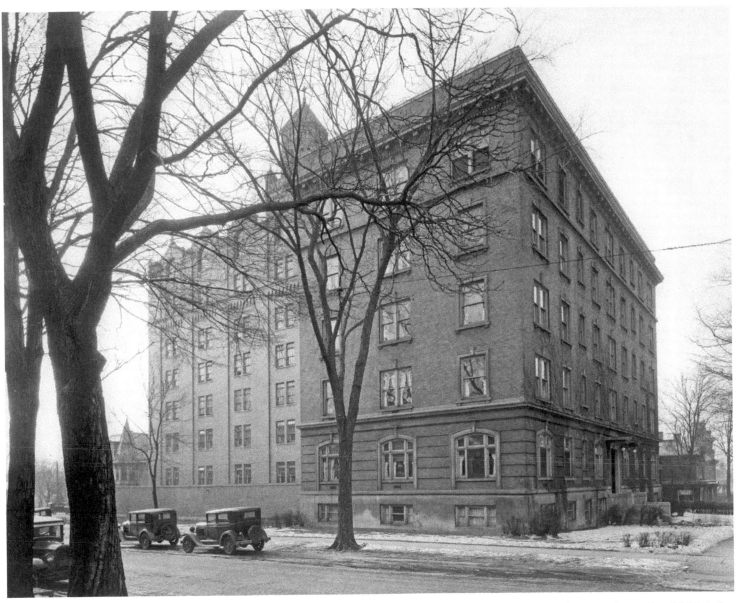

Saint Mary's Hospital, now Saint Mary's Mercy Medical Center. This view shows the old McAuley Building, which was torn down in 2001, as the Saint Mary's complex grew.

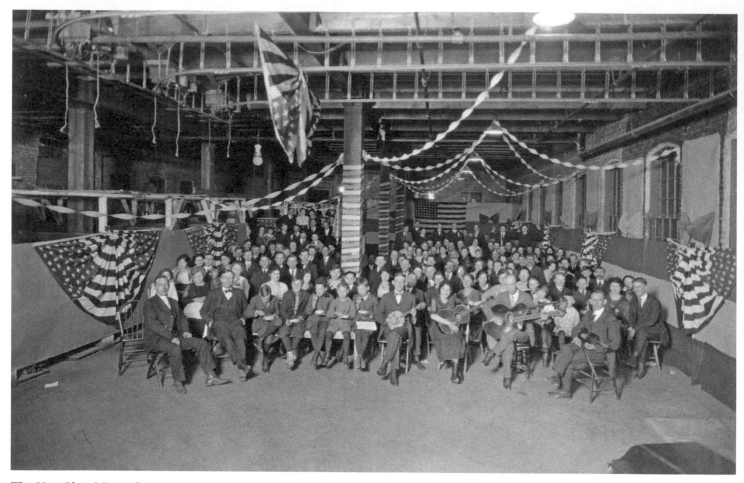

The Hart Plate Mirror Company employees and their families enjoy an indoor picnic sponsored by the Y.M.C.A. Industrial Services.

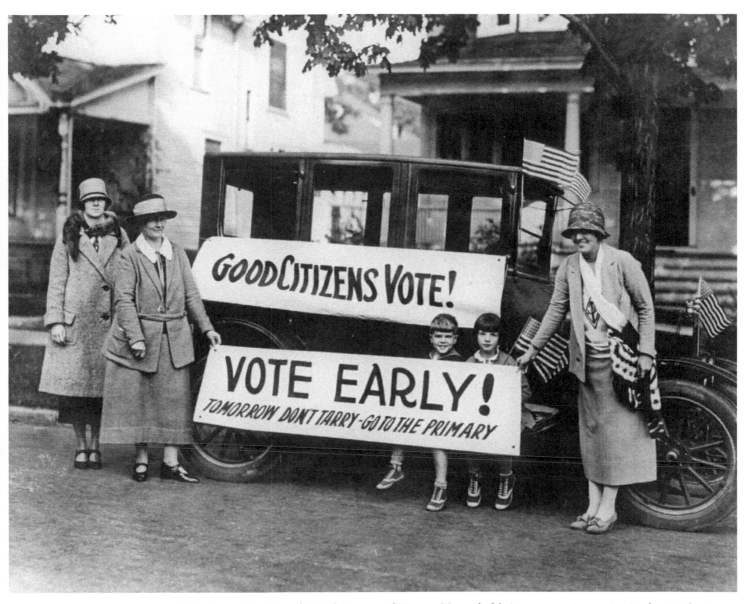

Members of the Grand Rapids League of Women Voters hold signs promoting voting in the 1924 primary election. David and Mary Amberg sit next to their mother, Mrs. Julius H. Amberg. On the left side is Miss Florence Shelley and Miss Grace Van Hoesen.

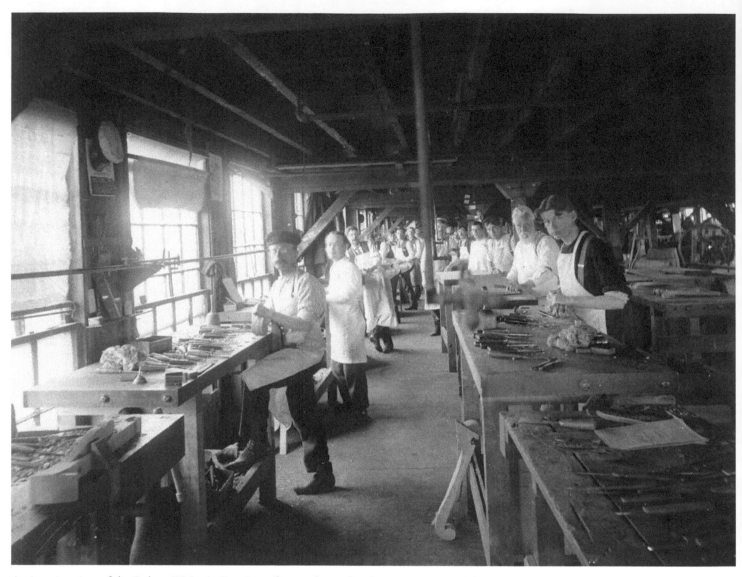

An interior view of the Robert W. Irwin Furniture factory, located at 432 Monroe NW. The company was in operation from 1919 to 1953.

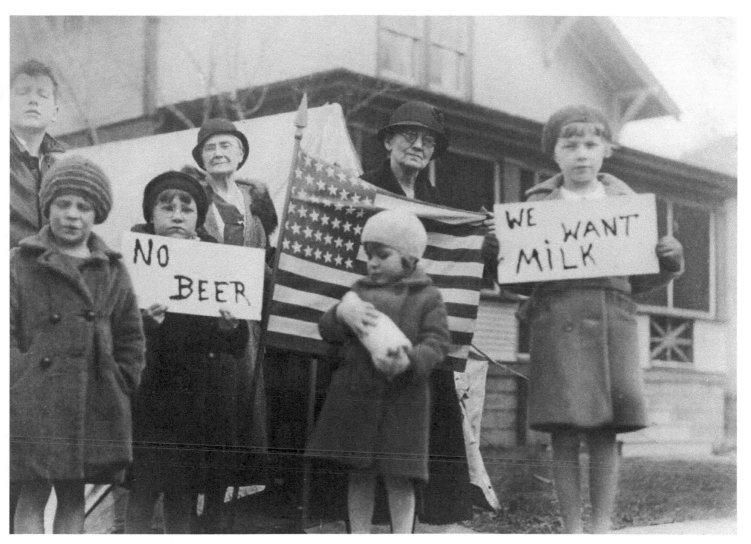

Area residents in support of Prohibition.

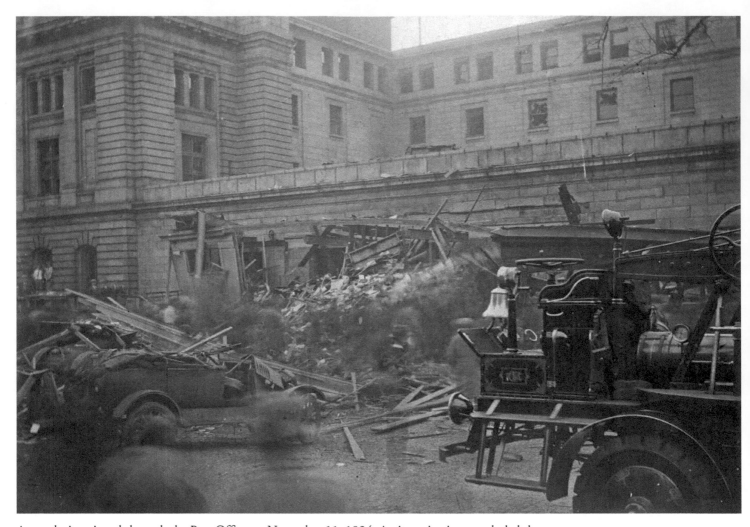

An explosion ripped through the Post Office on November 11, 1924. An investigation concluded that
the explosion was caused by ignition of illuminating gas escaping from a broken main on Division
Avenue. Three persons were killed and more than twelve injured.

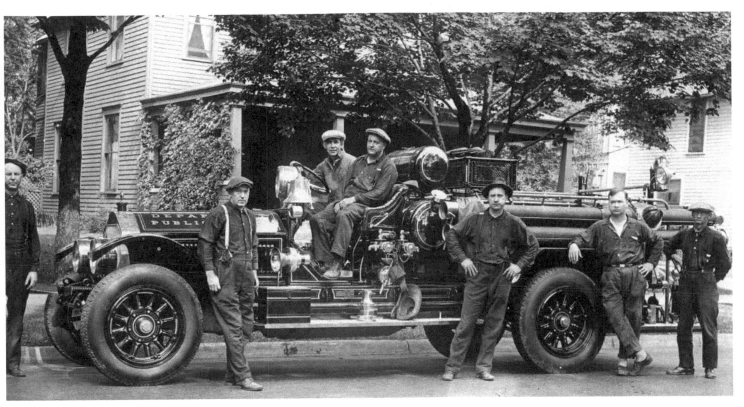

A Grand Rapids Fire Department crew poses with fire truck in 1926.

Two "Polar Bears" at the Grand Rapids Airport in 1927. These veterans had been part of a contingent of troops nicknamed Polar Bears, many of them from Michigan, sent on a mission to Russia during World War I.

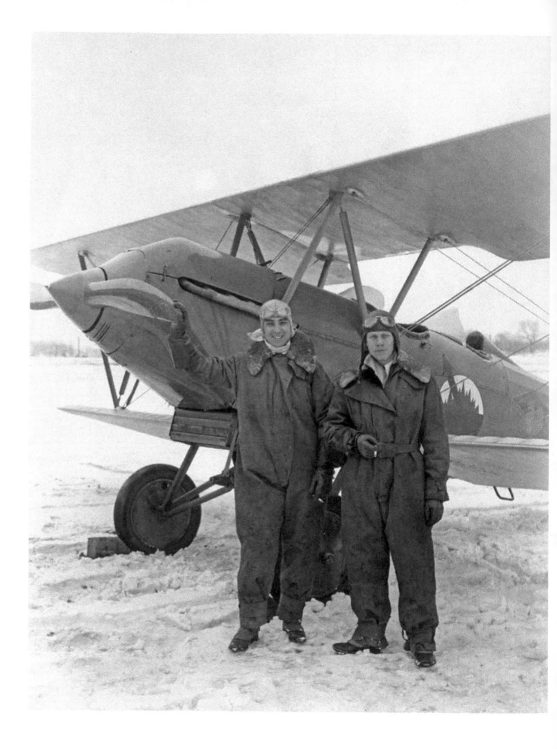

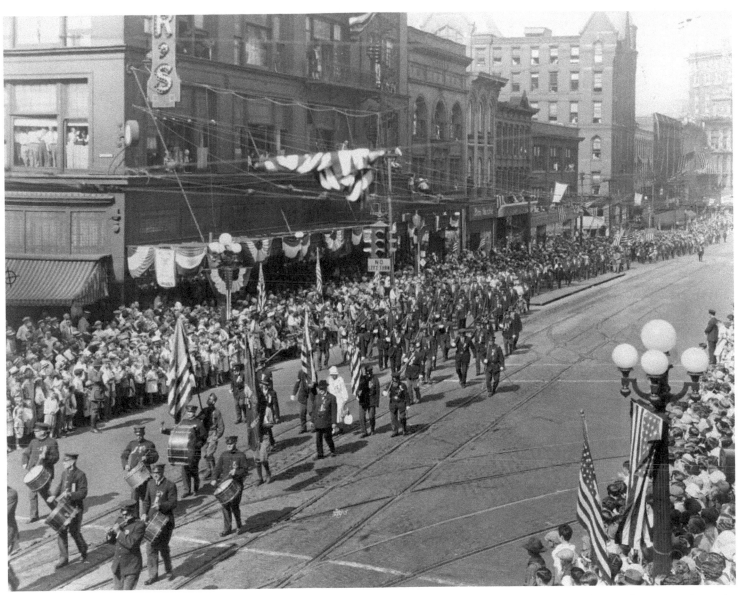

Citizens turn out to show their support of area veterans during this veterans' parade.

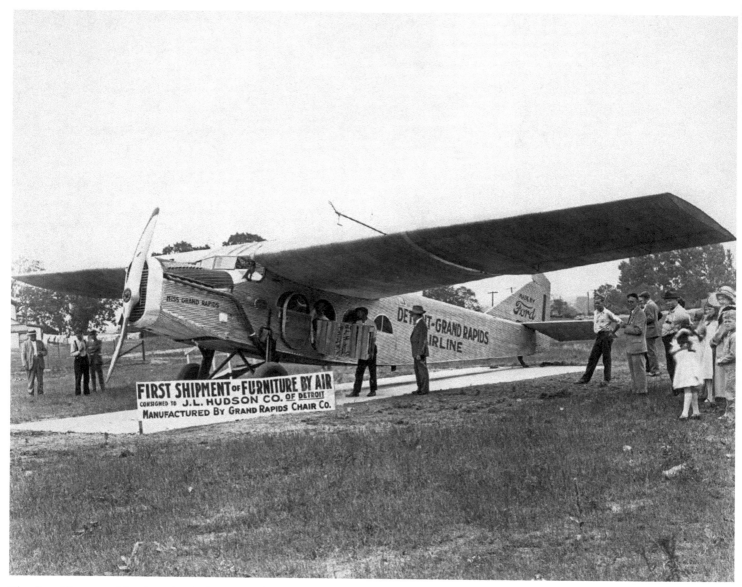

The first shipment of furniture by air from Grand Rapids to Detroit on the Ford-Stout airplane Miss Grand Rapids. This shipment was bound for the J. L. Hudson Company.

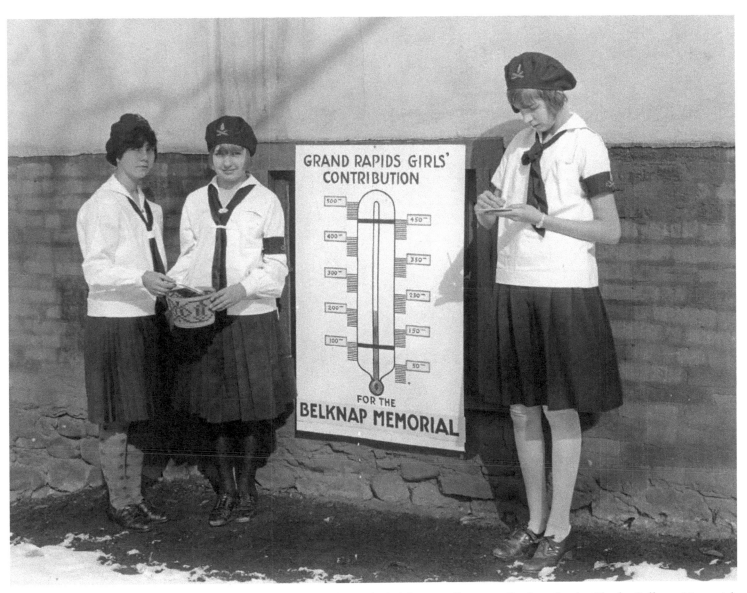

Grand Rapids Girl Scouts collect contributions for the Charles Belknap Memorial.

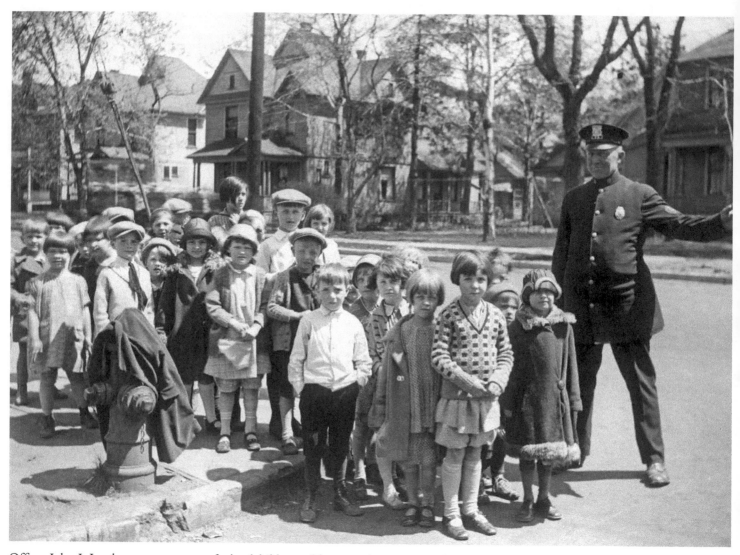

Officer John J. Lemke escorts a group of schoolchildren safely across the street near Congress School.

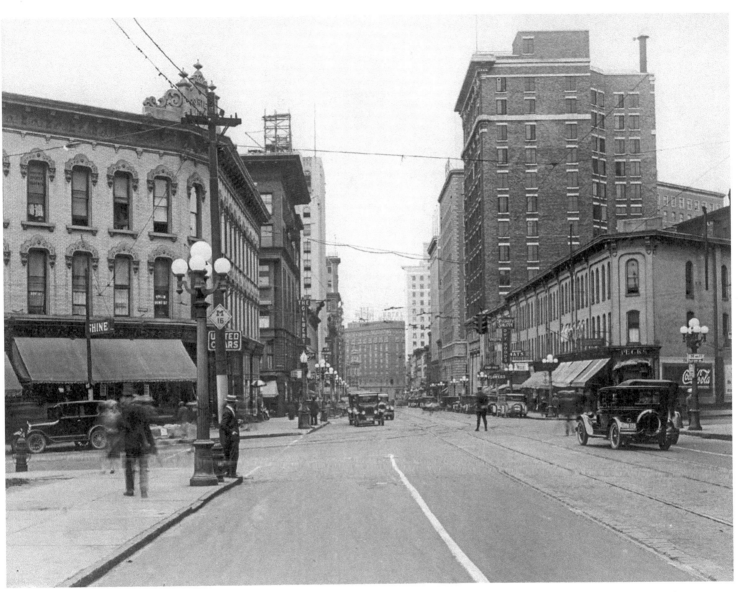

Monroe Avenue at Division, facing west.

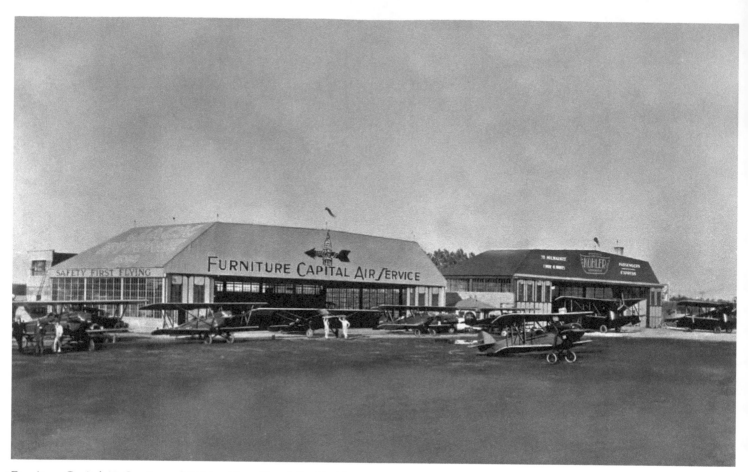

Furniture Capital Air Service and Kohler Air at Grand Rapids Airport.

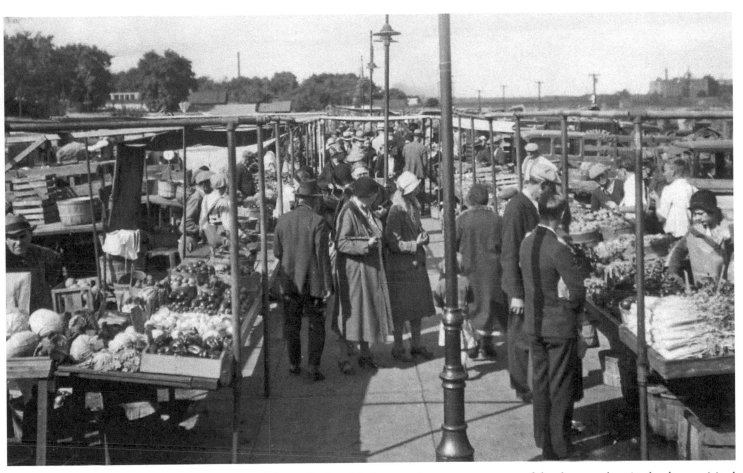

Leonard Street Produce Market was the most prosperous of the three markets in the days revisited here. At one time, 560 loads had come into the market, more loads than stalls.

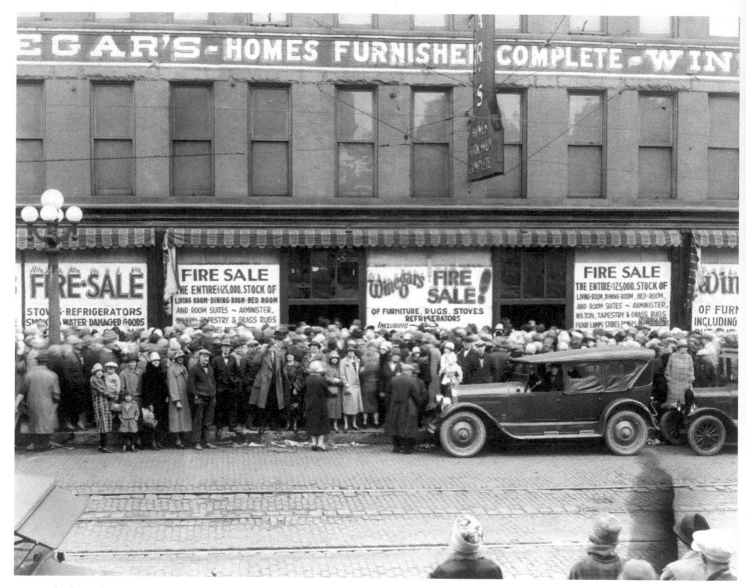

A crowd of people stands outside Winegar Furniture Store at 201-207 South Division Street. Winegar's was holding a "Fire Sale"—with the entire stock of furniture, rugs, and appliances at reduced prices.

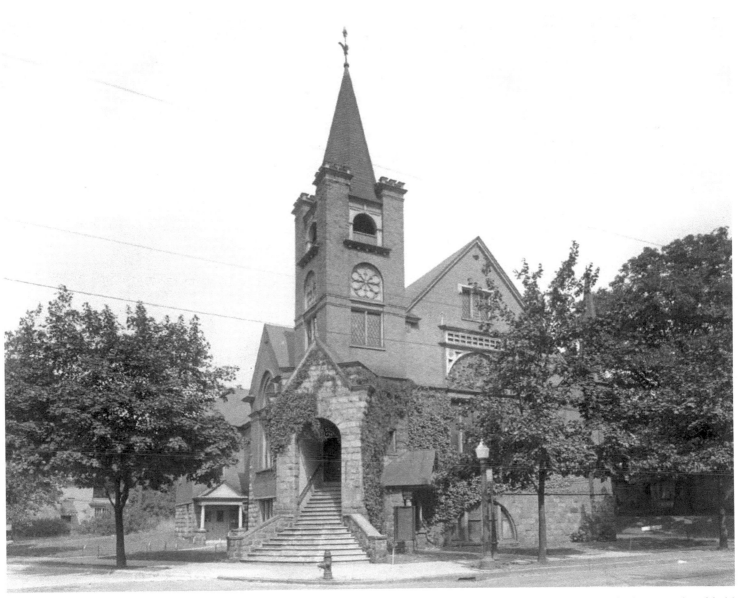

The Second Congregational Church, located at 1331 Plainfield Avenue NE, was built in 1874 and held services regularly until 1950.

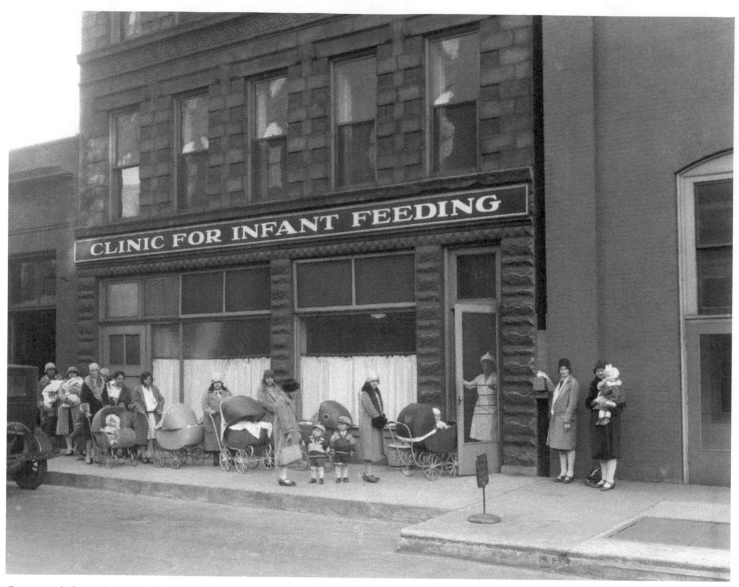

Concerned about the city's high rate of infant mortality in the early years of the twentieth century, socially conscious women formed seven infant clinics, such as this one at 112 Louis NW, to instruct new mothers in the care of their babies.

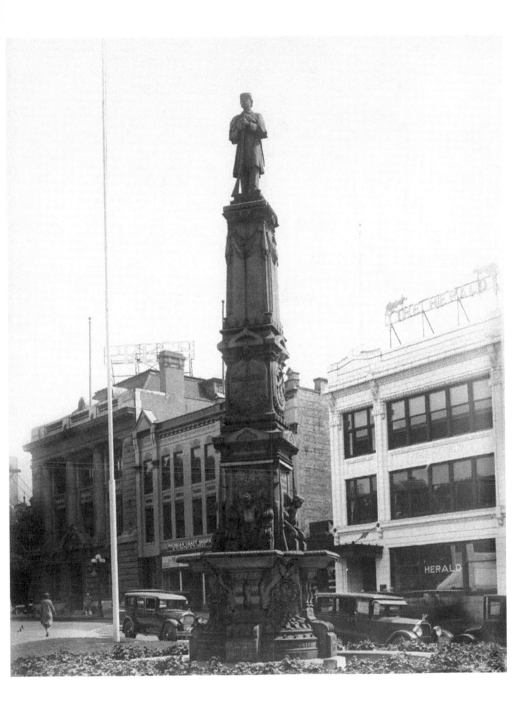

The Civil War Monument was constructed and dedicated in 1885. The dedication featured a twomile parade through downtown Grand Rapids, which drew crowds of more than 3,000 veterans and 30,000 spectators. The monument's original white bronze developed a Confederate gray patina, which caused a local uproar that led to the painting of the monument a Union blue. The Civil War Monument was restored in 2006.

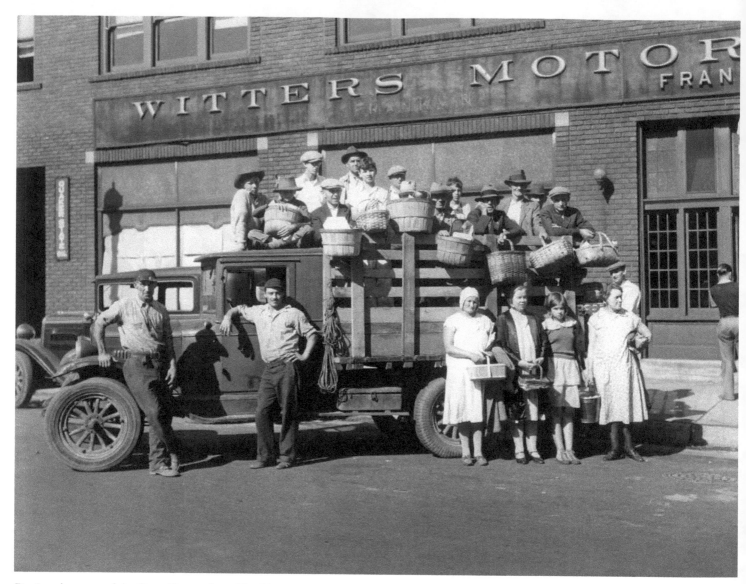

During the years of the Great Depression, City Manager George Welsh instituted a scrip wage system and set up a municipal food store. As many as 60 work projects were underway at the same time. Playgrounds and parks were reconditioned. Flood-inducing obstructions in the river were removed. Streets were graded and repaired. This image shows berry pickers leaving for the fields, another work project that was part of the program.

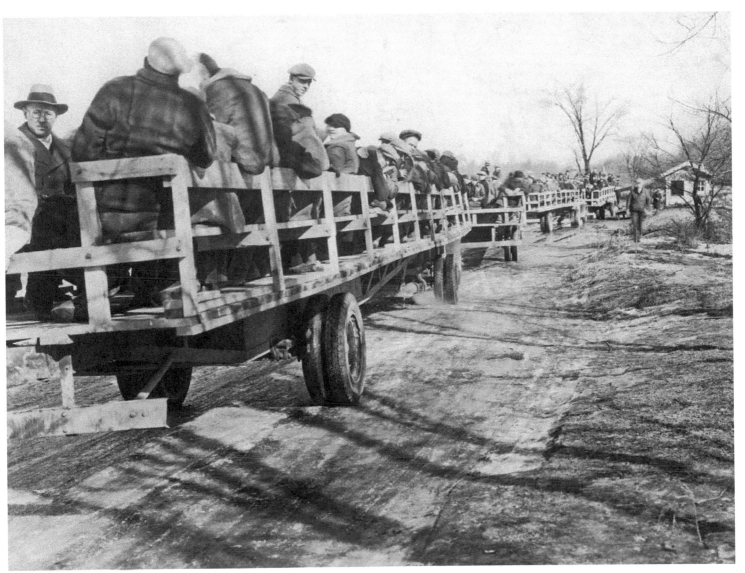

These scrip laborers are ready to depart for the various work-projects job sites.

These scrip laborers are laying pipe at Front Avenue and Third Street in 1931.

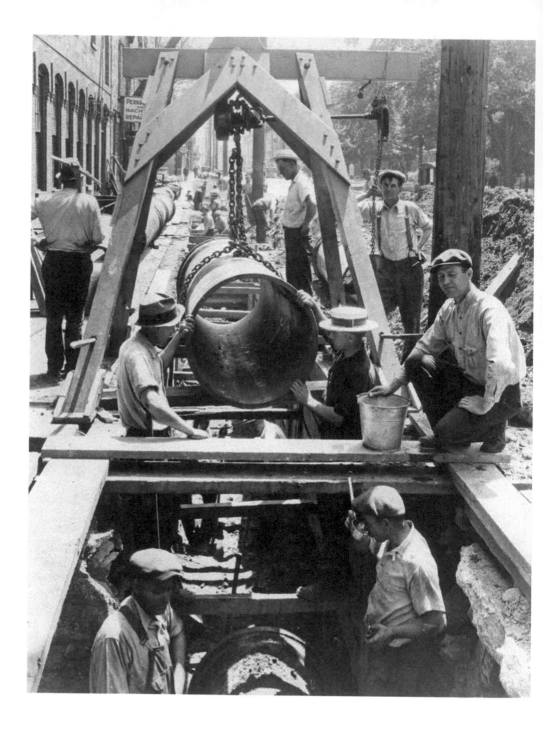

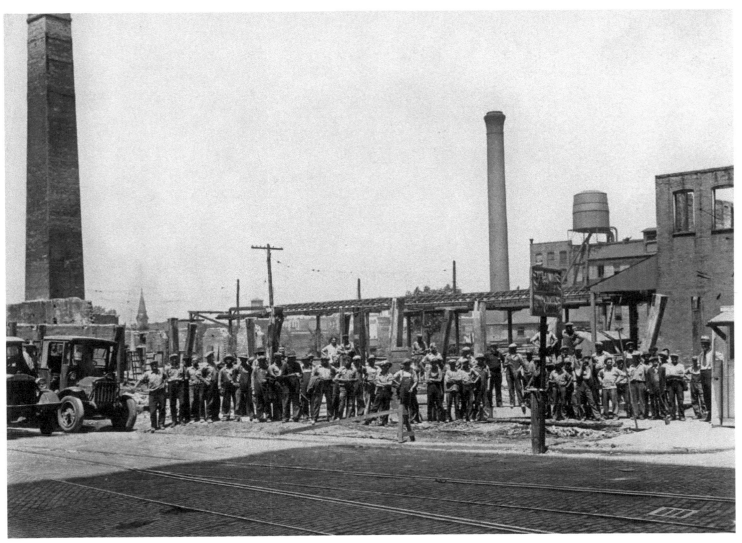

Scrip laborers line up for work at an area job site.

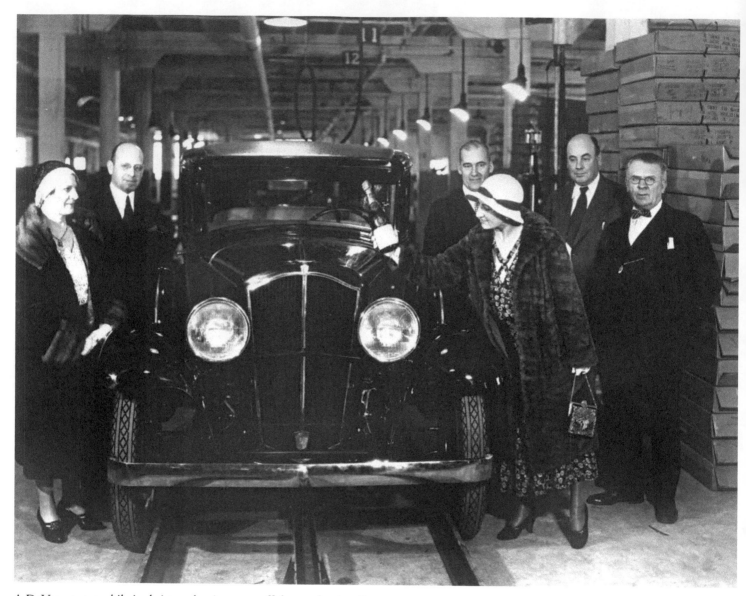

A DeVaux automobile is christened as it comes off the production line.

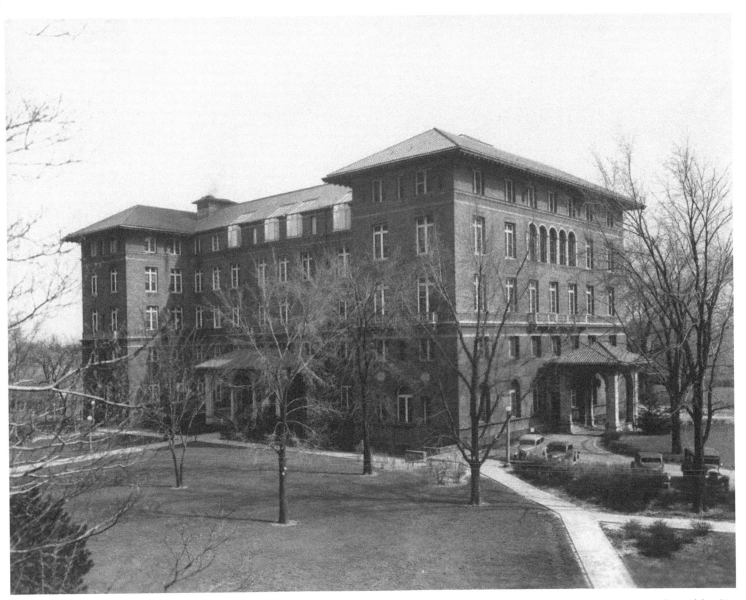

Blodgett Hospital, now known as Spectrum Health-Blodgett Campus, at Plymouth and Wealthy SE. John Blodgett, Sr., and his wife, Minnie Cumnock Blodgett, donated land and funds in 1914 for construction of the hospital.

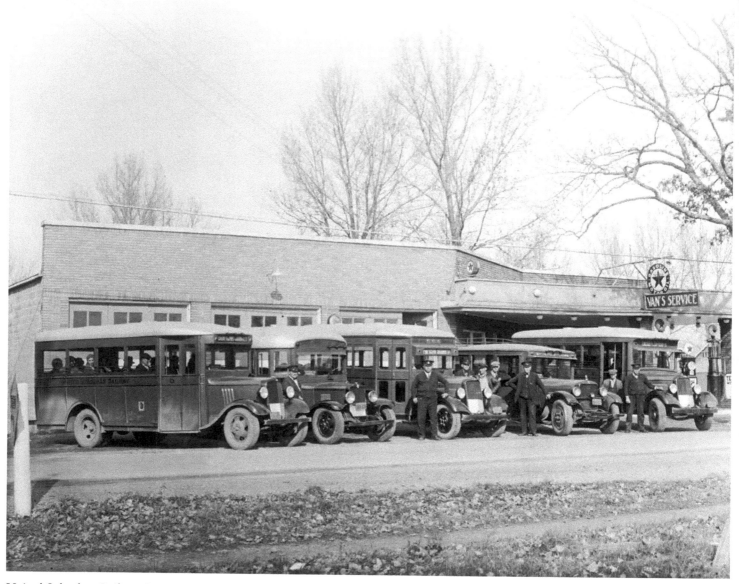

United Suburban Railway Bus Line served transportation needs from Grand Rapids to Grandville. Stations were located on Louis, Market, Ottawa, and West Washington streets.

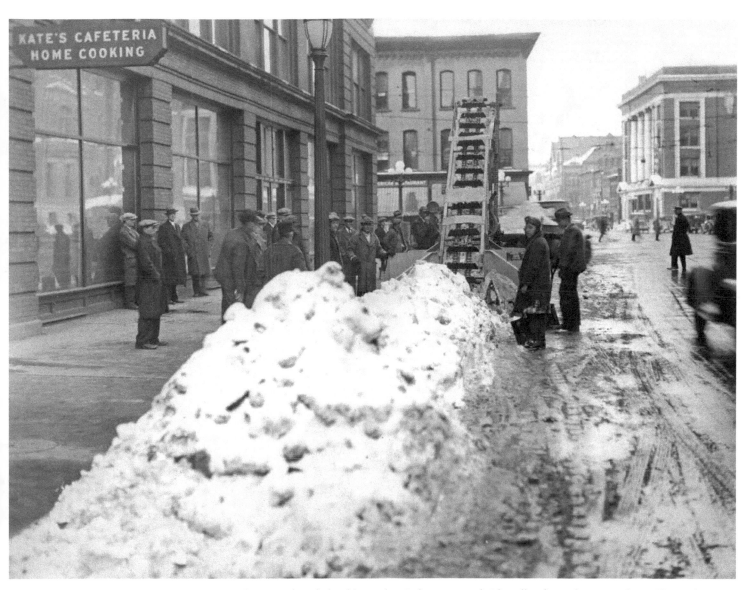

Scrip workers helped keep the city's streets and sidewalks clear of snow and ice. Shown here, an elevator is being operated to load mounds of snow onto a waiting dump truck.

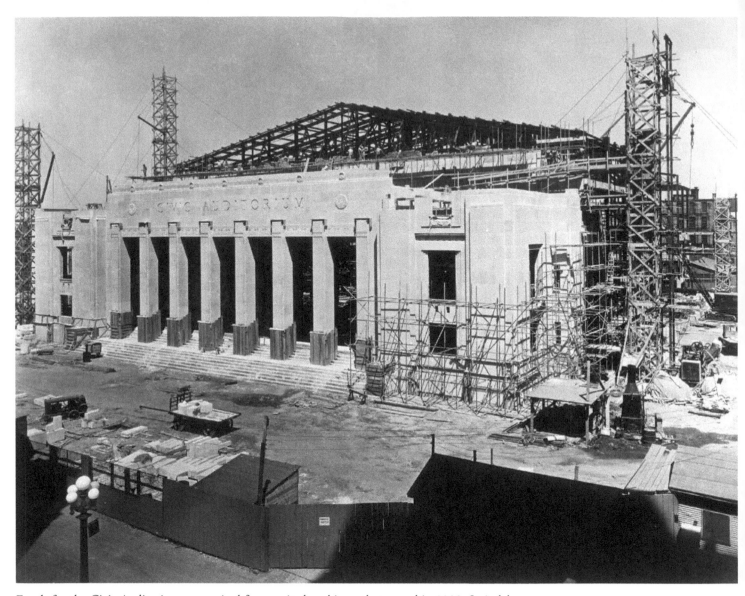

Funds for the Civic Auditorium were raised from a city bond issue that passed in 1932. Scrip laborers provided the manpower for construction. The auditorium was dedicated in 1933.

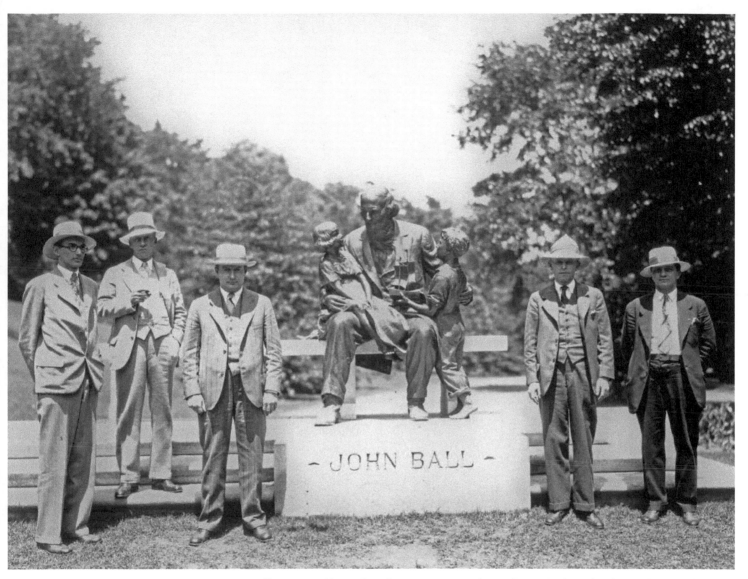

John Ball was a world traveler who came to Grand Rapids in 1836 as a land speculator. Ball left 40 acres to the city upon his death, which became John Ball Park and Zoo. This monument in tribute to Ball was based on a sketch by Gertrude Vande Mark, a local artist, and was sculptured by Pompeo Coppini in 1925.

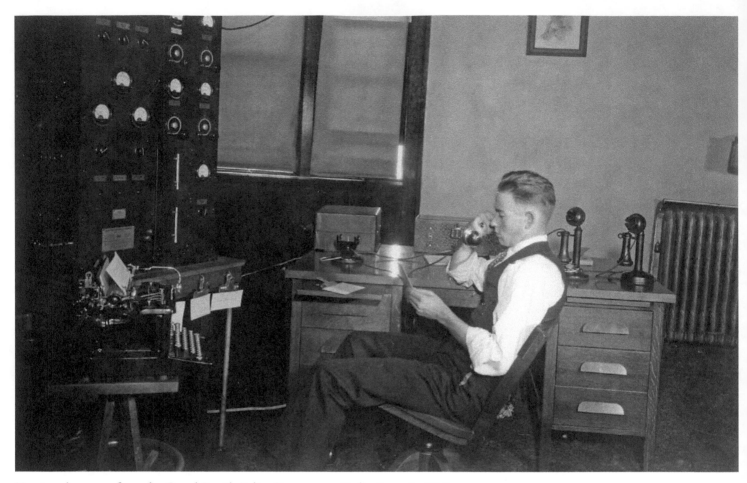

Keeping the peace, from the Grand Rapids Police Department Radio Room in 1932.

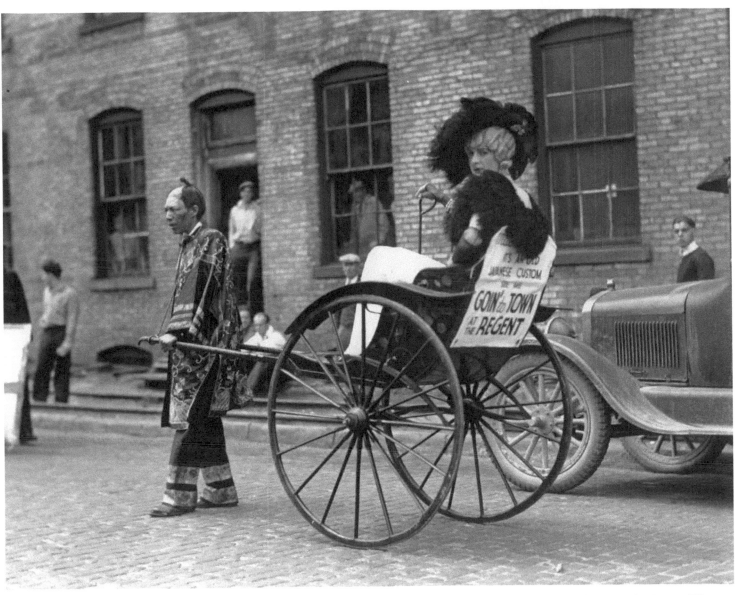

Promotion for the Mae West movie Going to Town. The film was being shown at the Regent Theater.

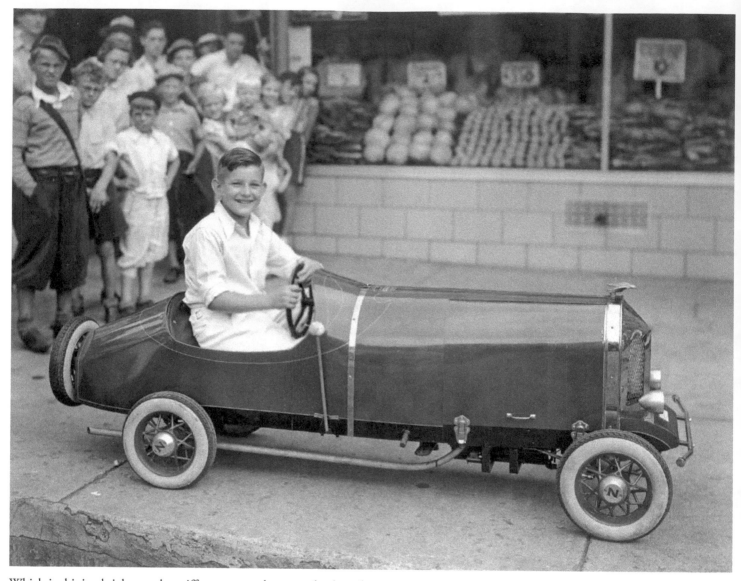

Which is shining brighter—the spiffy toy car or the young boy's smile?

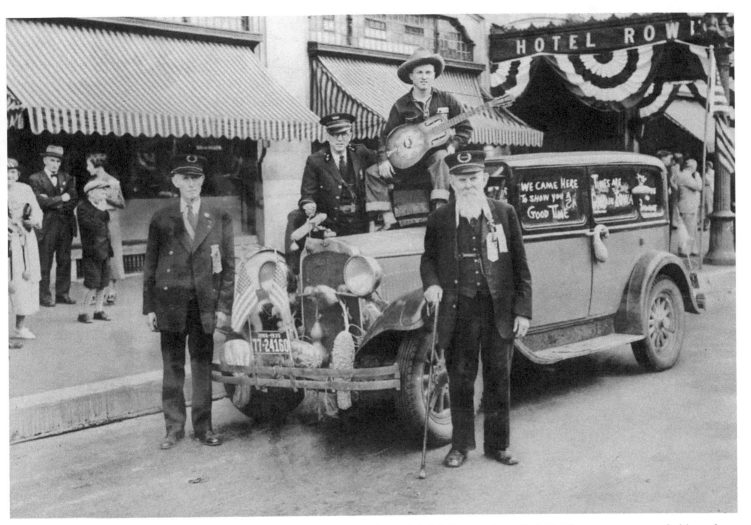

The Grand Army of the Republic (G.A.R.) Convention of 1935. These veterans traveled here from Iowa to take part in the festivities.

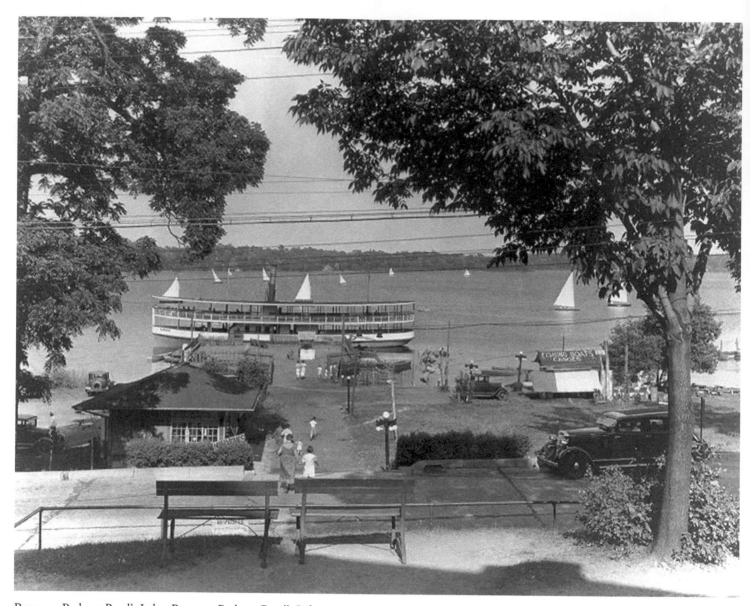

Ramona Park, at Reed's Lake. Ramona Park, at Reed's Lake.

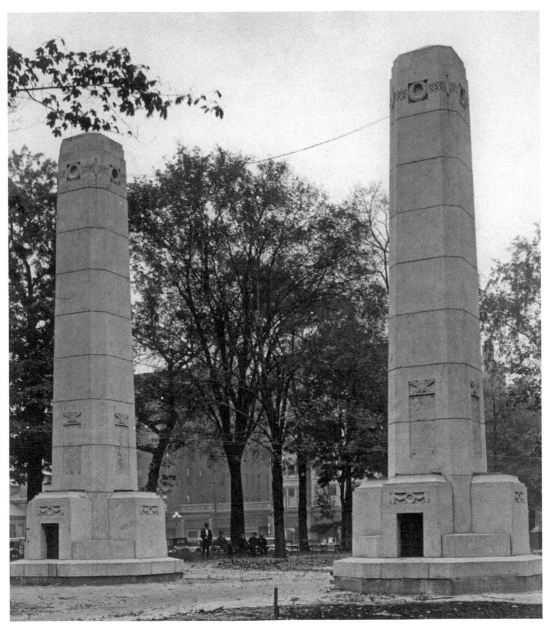

Inspired by Egyptian architecture, the Veteran's Memorial Pillars symbolize hope and freedom. The pillars were inscribed with the names of the dead from World War I. Later, the names of casualties from World War II and the Korean War were added.

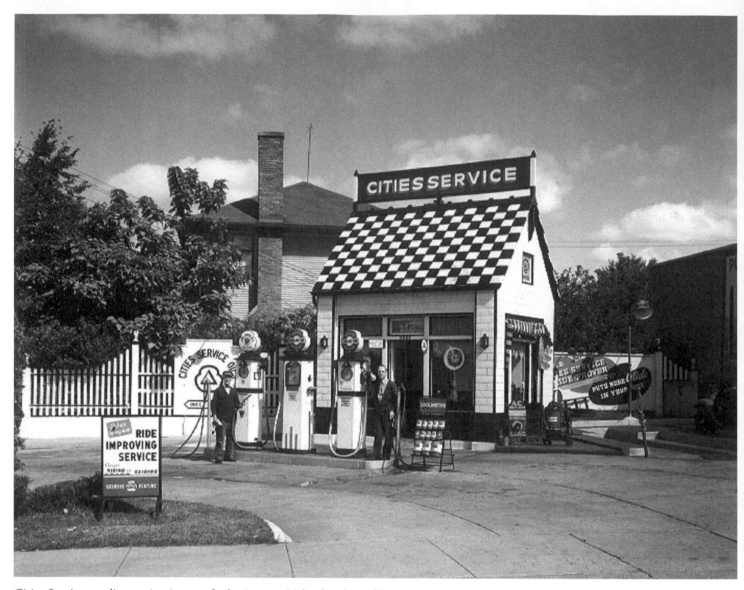

Cities Service gasoline station is open for business at Neland and Franklin SE.

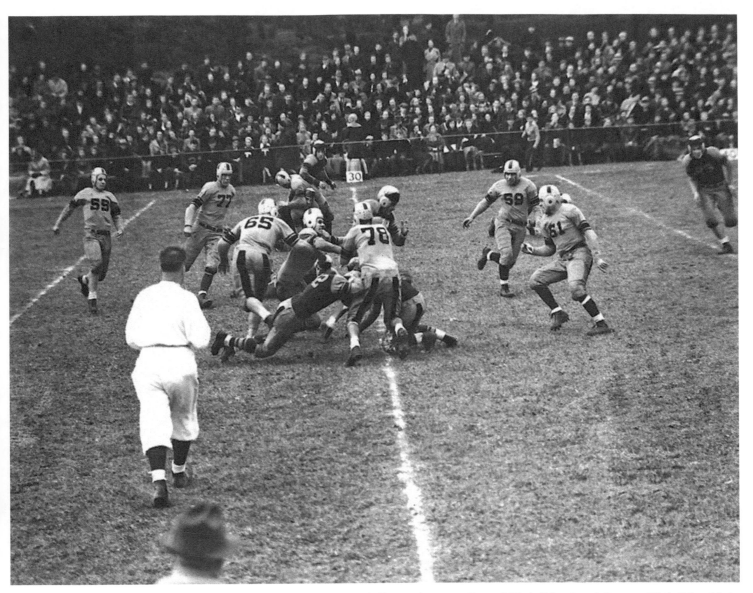

A Saturday afternoon football game between Central High School and Creston High School is in progress October 9, 1937. The game ended in a 6–6 tie.

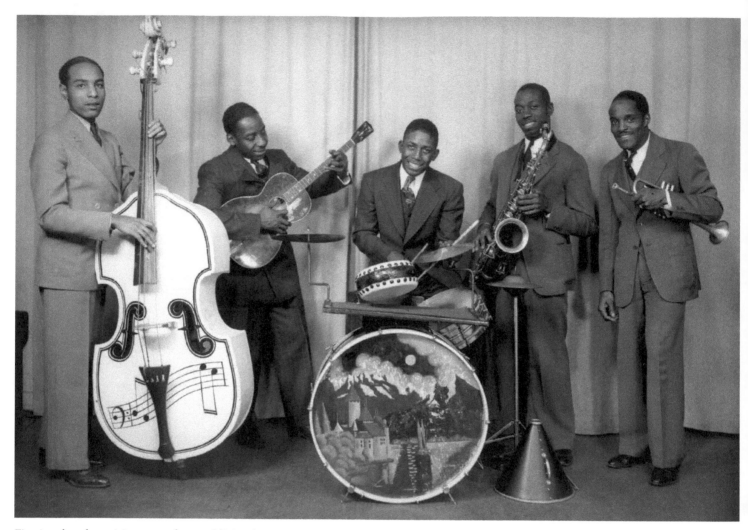

Five jazz band musicians pose for a publicity shot.

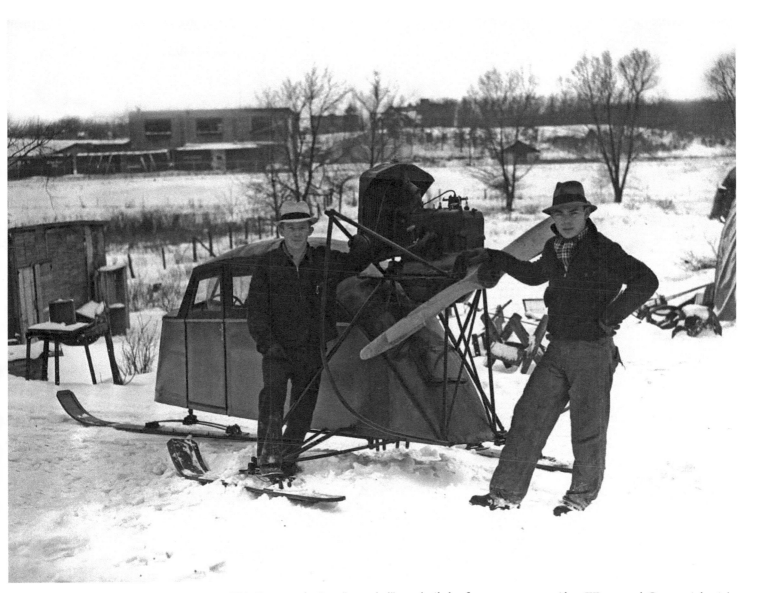

This "snow sedan" or "aero sled" was built by four young men, Alex, Water, and George Adastick, and Joe Svoboda. It was powered by a four-cylinder automobile motor equipped with a two-blade propeller. The body was made from aircraft plywood and seated two persons. The machine ran on three runners, or skis, about six feet long.

The F. W. Woolworth Co. dimestore was located at 169 Monroe, at the corner of Pearl Street.

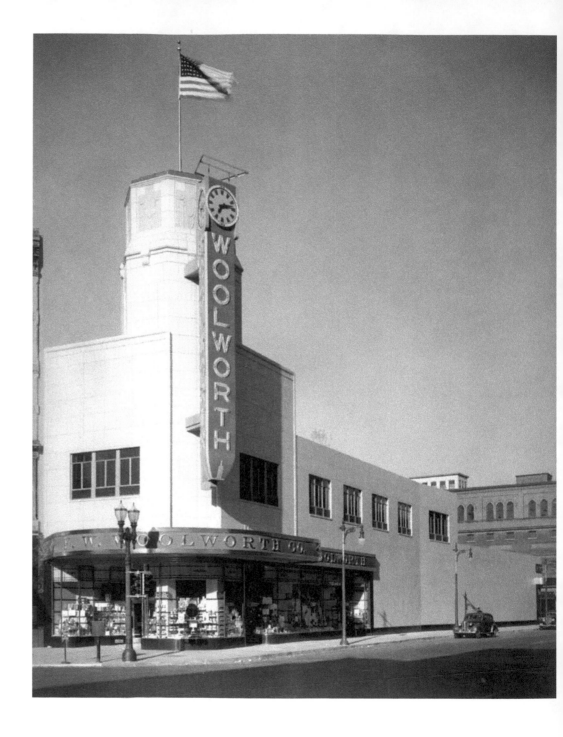

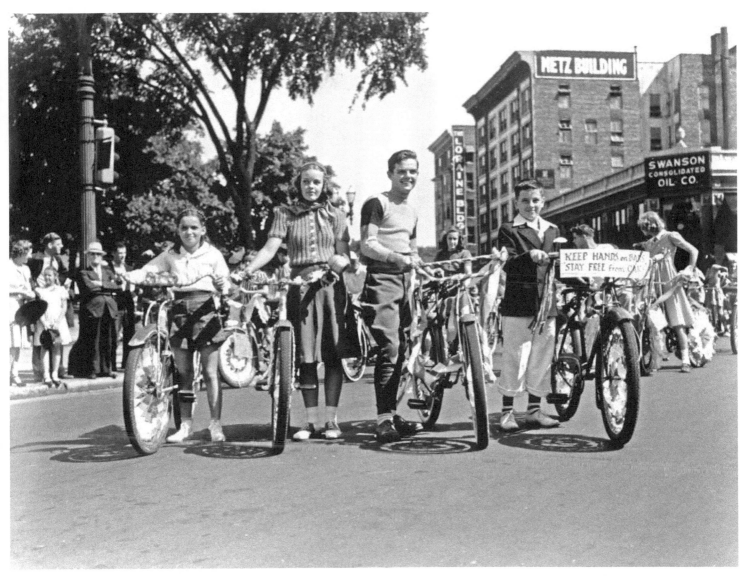

More than 200 children joined the Bike Safety Club parade on September 6, 1939.

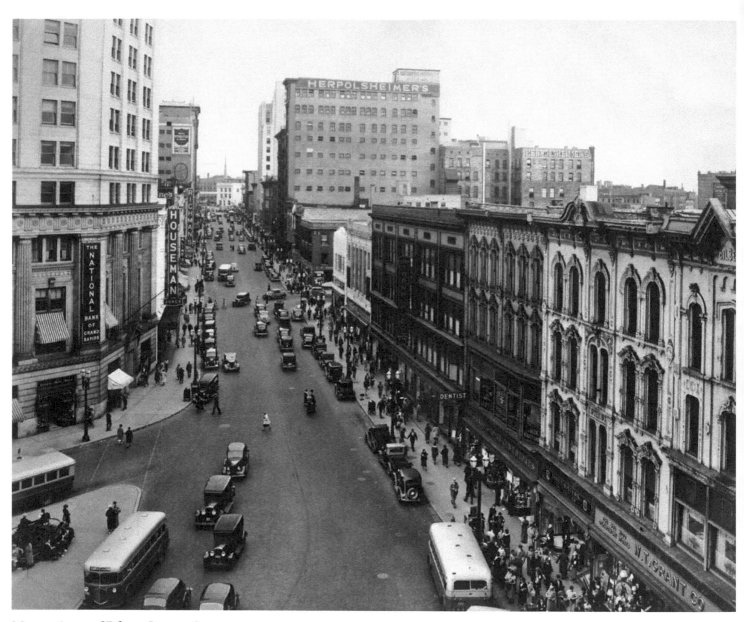

Monroe Avenue SE from Campau Square.

WORLD WAR II AND BEYOND

(1940–1950s)

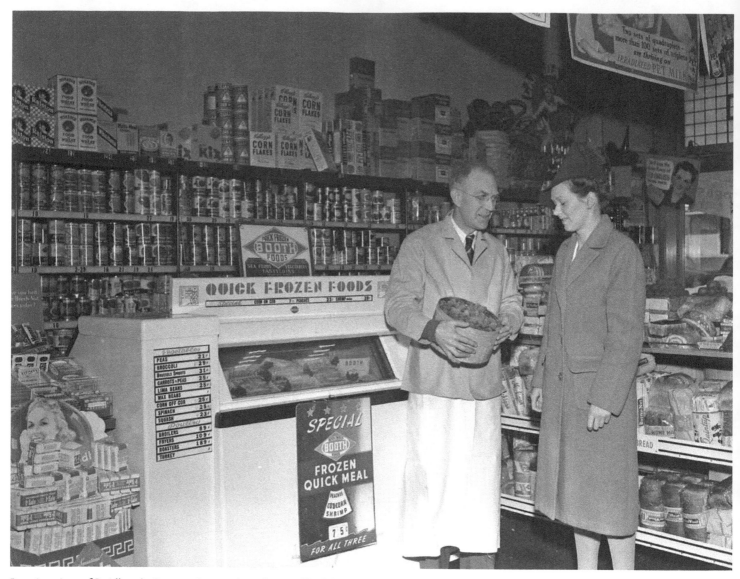

Interior view of Luidberg's Grocery Store, where "corn off cob" is a quarter, and Woodbury soap is on sale for a penny.

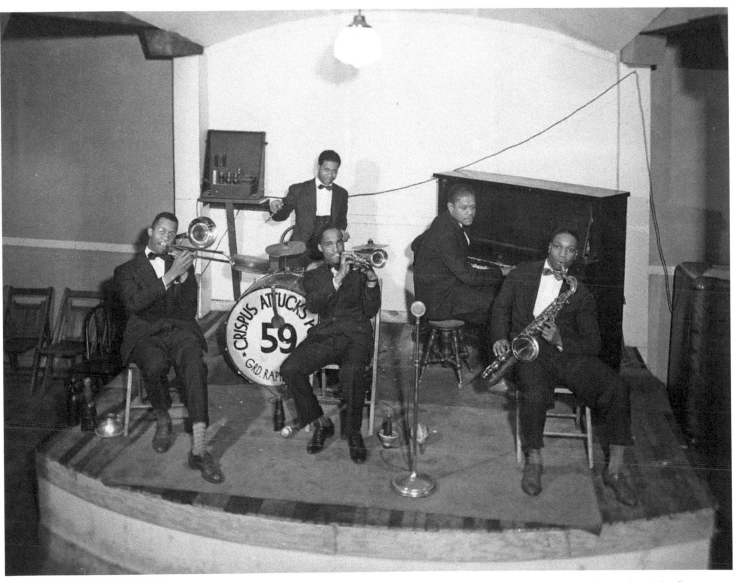

A concert is underway at the Crispus Attucks Post of the American Legion, located at 245 Commerce SW.

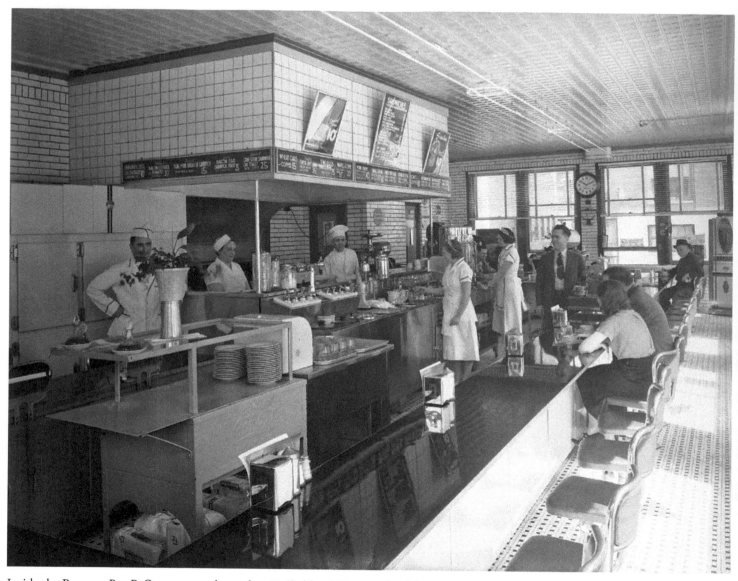

Inside the Banquet Bar-B-Q restaurant, located at 33 Sheldon NE, specials of the day include a bacon, lettuce, and tomato sandwich for 20 cents.

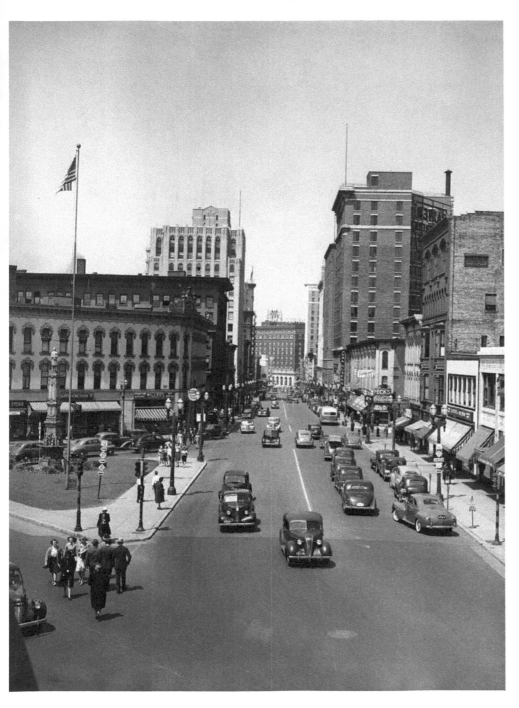

Monroe Avenue as it appeared in 1941. The Civil War Monument is visible to the left.

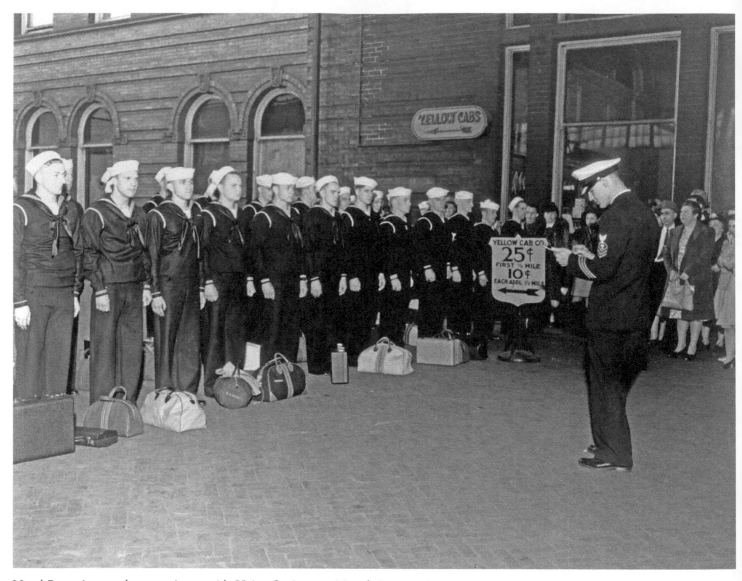

Naval Reservists stand at attention outside Union Station, awaiting their seat assignments.

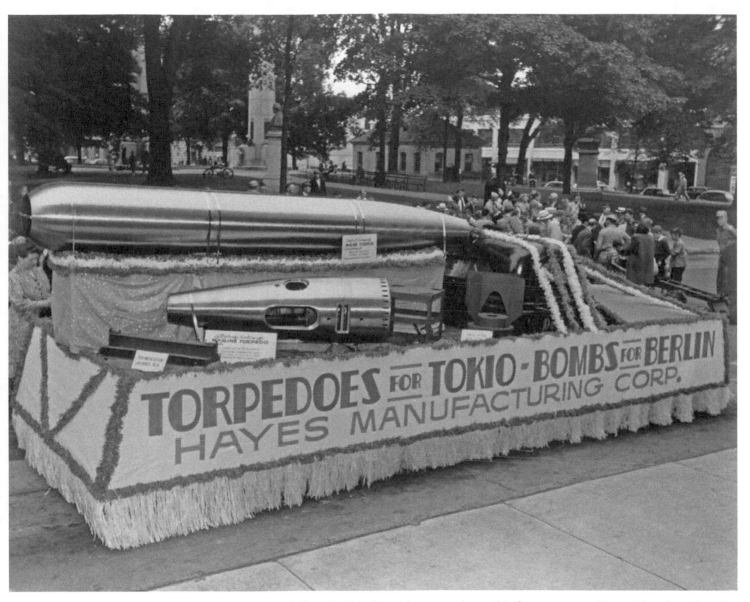

In a parade featuring locally made war products, this float represents Hayes Manufacturing. On display are a marine torpedo, a fragmentation grenade box, and a torpedo tail fin.

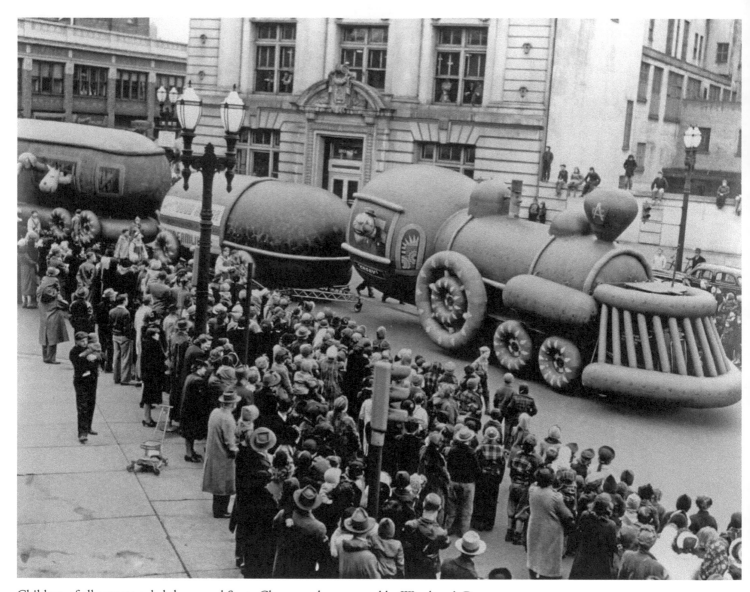

Children of all ages attended the annual Santa Claus parade sponsored by Wurzburg's Department
Store.

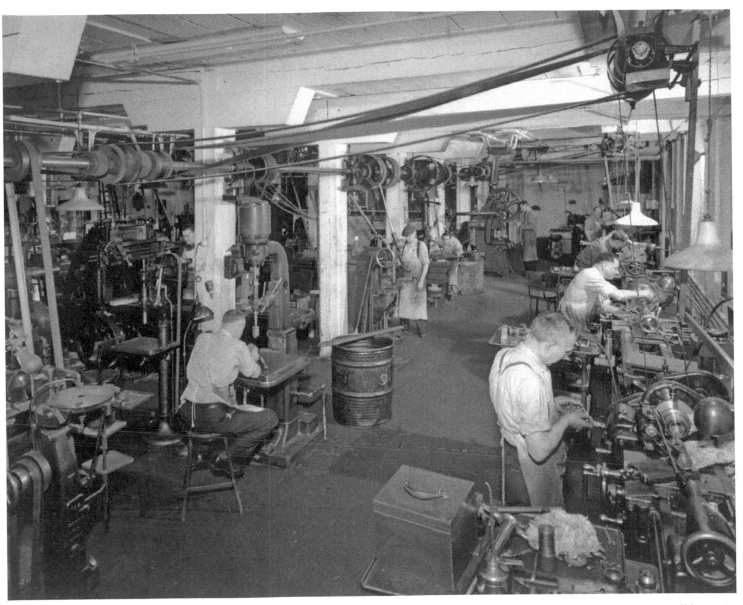

An interior view of the Bissell Carpet Sweeper factory, located at 210-218 Erie NW. Bissell began in 1876 and is still helping keep America clean.

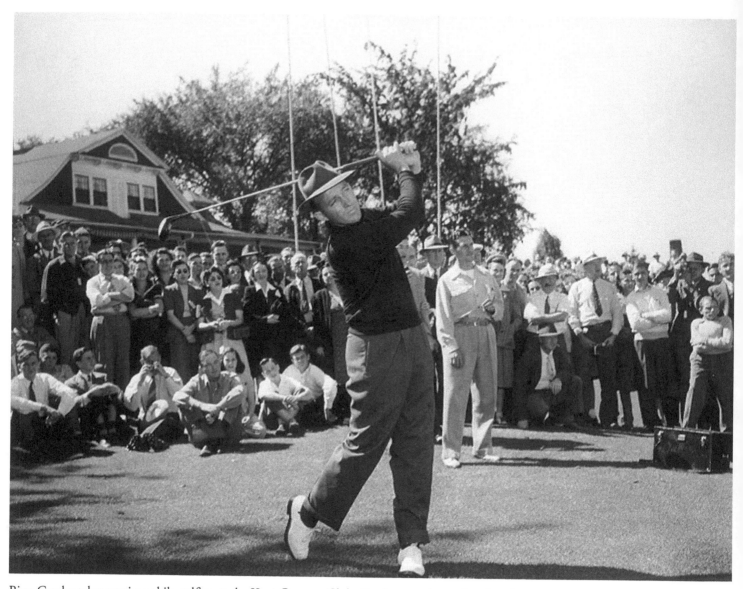

Bing Crosby takes a swing while golfing at the Kent Country Club. Crosby was playing in a benefit for the USO and Red Cross.

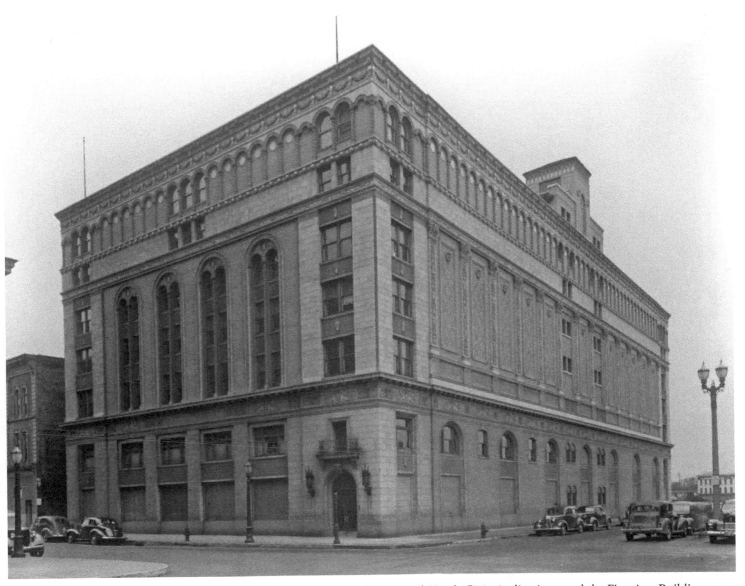

Several buildings, including the Pantlind Hotel, Civic Auditorium, and the Fine Arts Building, were converted during World War II into barracks, mess halls, classrooms, offices, and officer's quarters for the Weather Training School of the Army Air Forces Technical Training Command. Classes began in January 1943. By September, the school had closed.

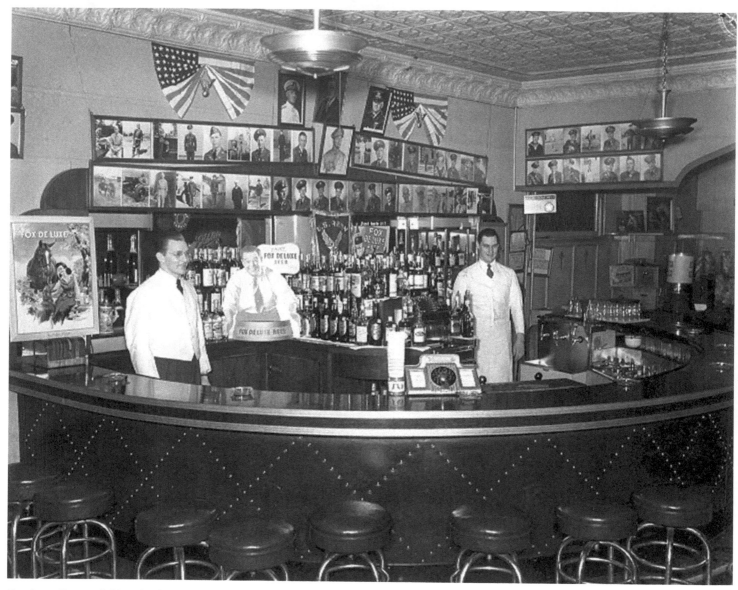

Brothers George (left) and John (right) Broekema, owners of the Silver Cloud Tavern, are shown honoring local soldiers and promoting Fox Deluxe Beer.

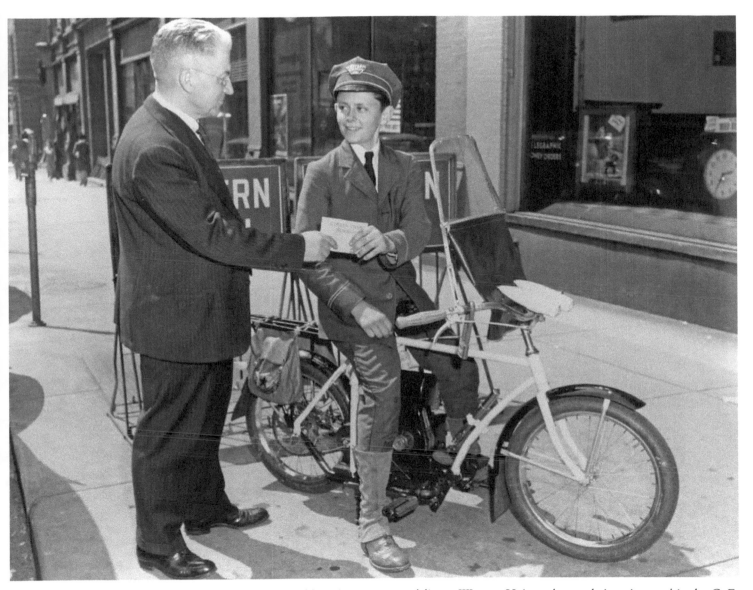

Harold Foote, with his motorized bicycle, prepares to deliver a Western Union telegram being given to him by C. E. Carpenter.

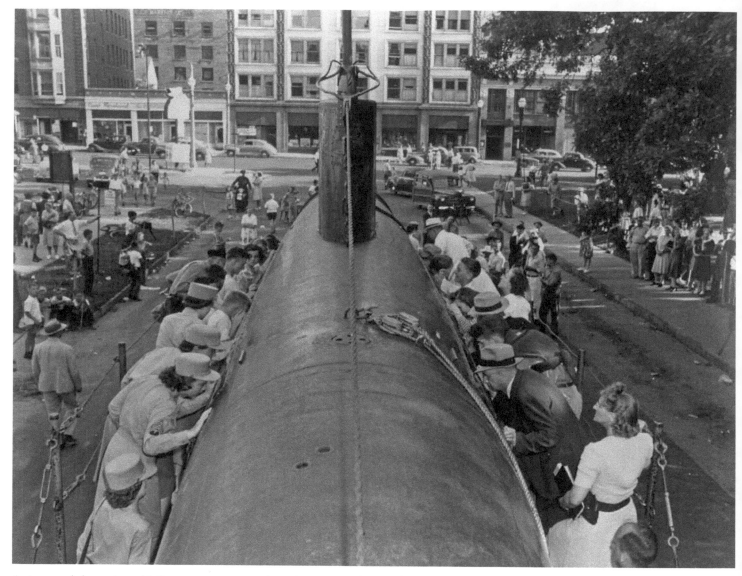

As it toured the nation, this Japanese two-man submarine, captured at Pearl Harbor, helped raise funds for the war effort.

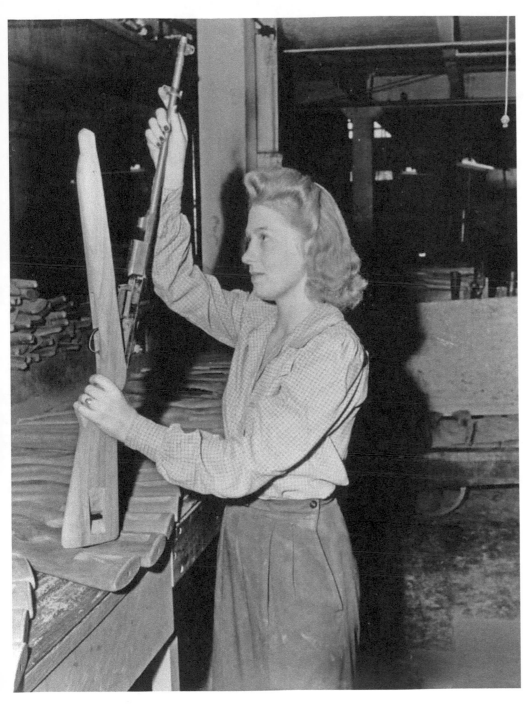

As an inspector for the Robert W. Irwin Company, Clara Bush made sure stocks were produced to specific standards. Bush sought work with the company after her brother was killed in action in the South Pacific.

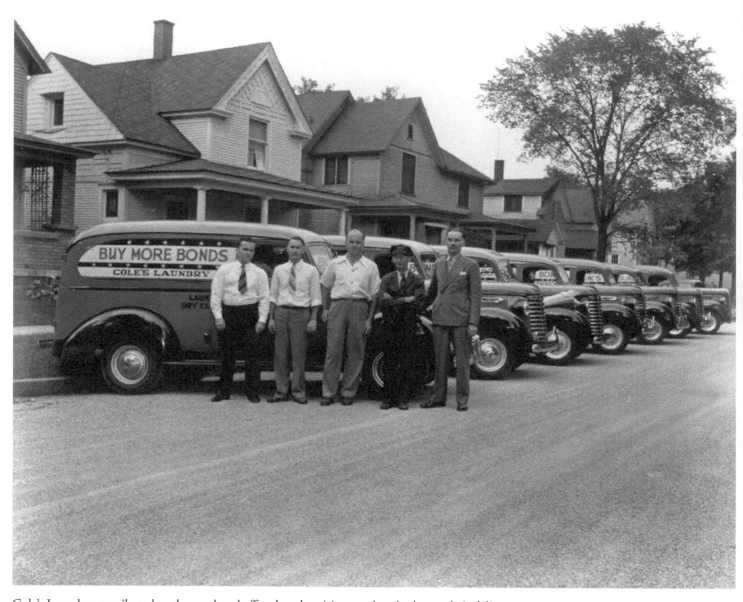

Cole's Laundry contributed to the war bond effort by advertising war bond sales on their delivery
trucks.

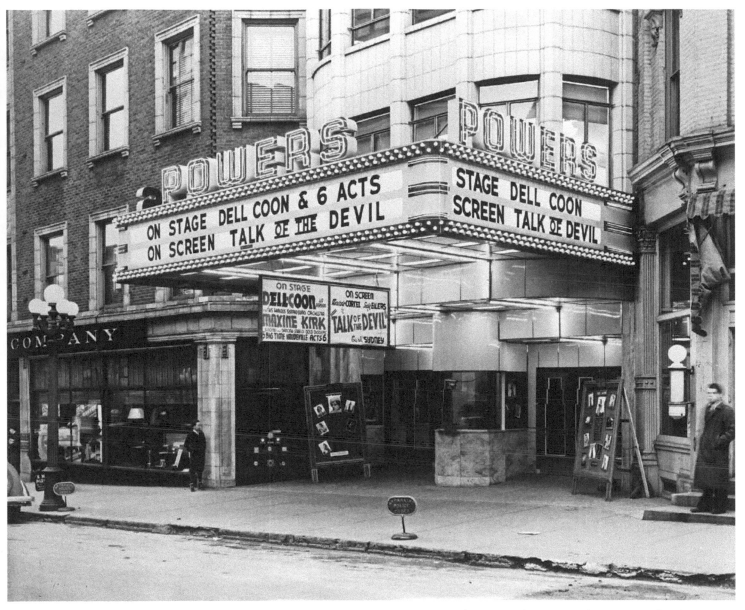

Now showing at the Powers Theater . . . Talk of the Devil.

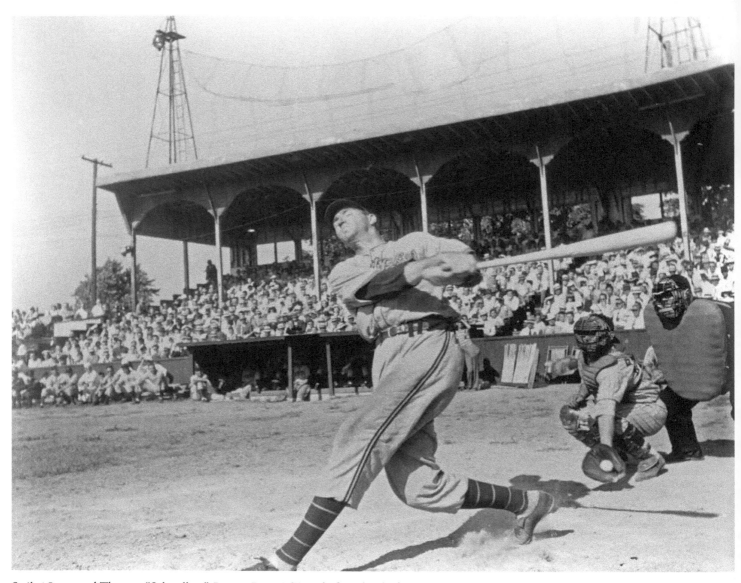

Strike! Lynwood Thomas "Schoolboy" Row, a Detroit Tiger before the draft, swings and misses as he plays with the Great Lakes Naval Station team against the Grand Rapids All-Stars.

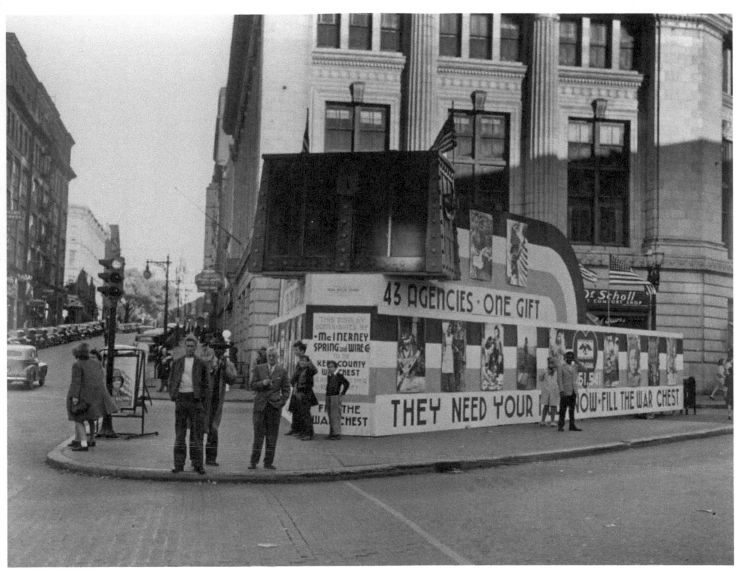

Fill the War Chest! The giant war chest on display at the McKay Tower recorded a goal of $851,541 for support of the war effort.

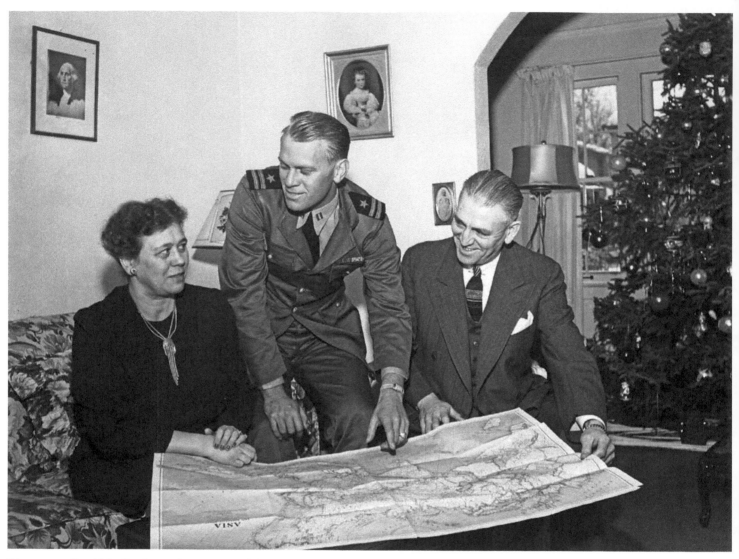

Lieutenant Gerald R. Ford visits his parents while en route to Washington, D.C., after serving in the South Pacific as an assistant navigation officer on a light aircraft carrier.

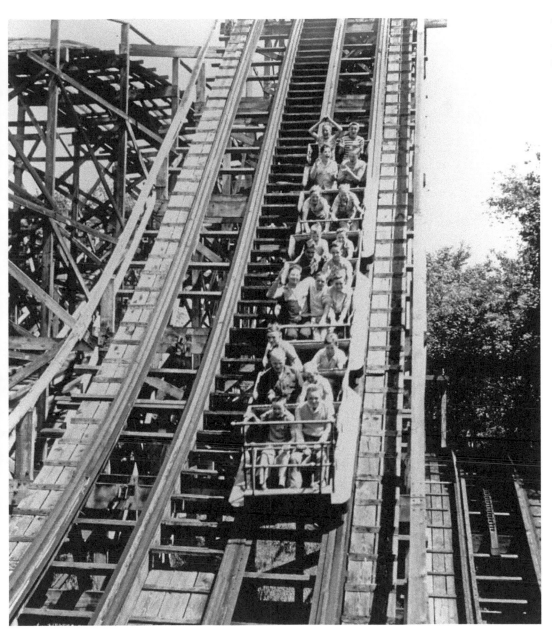

The Grand Rapids Herald newsboys enjoy the Derby Racer at Ramona Park.

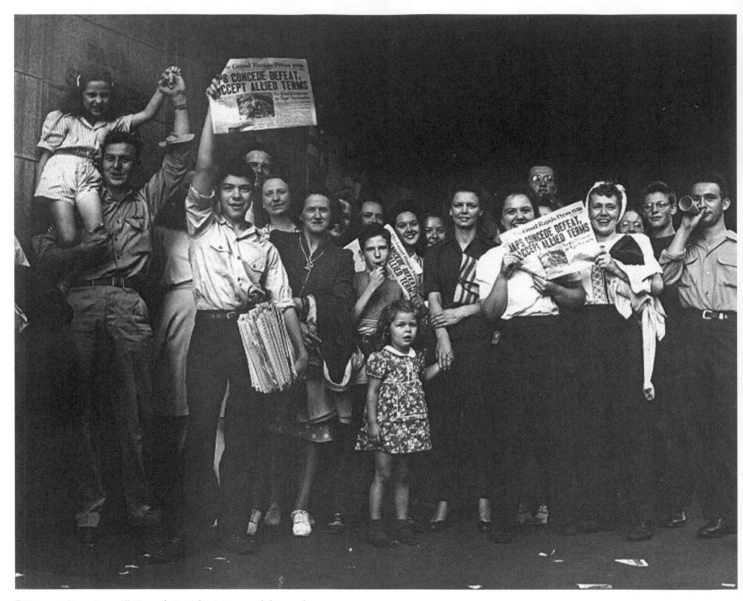

"Victory Over Japan!" Grand Rapids citizens celebrate the news.

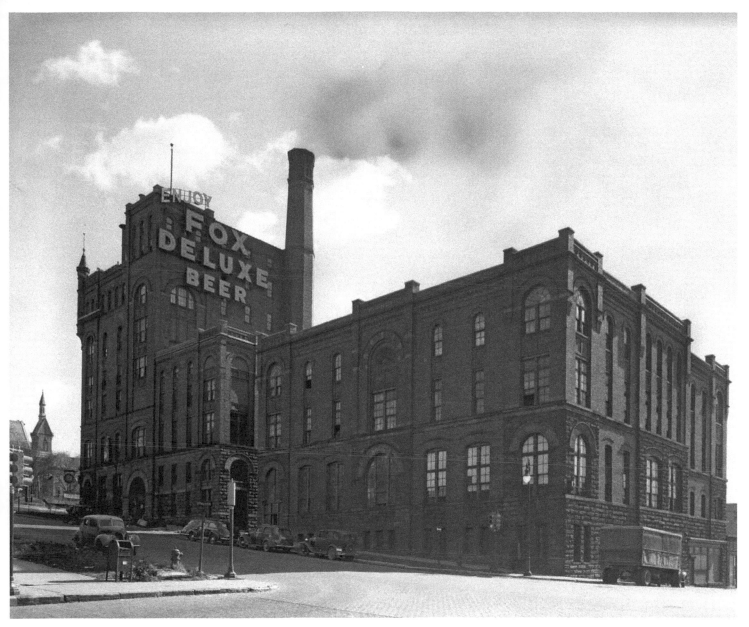

Fox Brewing Company, located at 26 Michigan NE, was in business from 1940 to 1951.

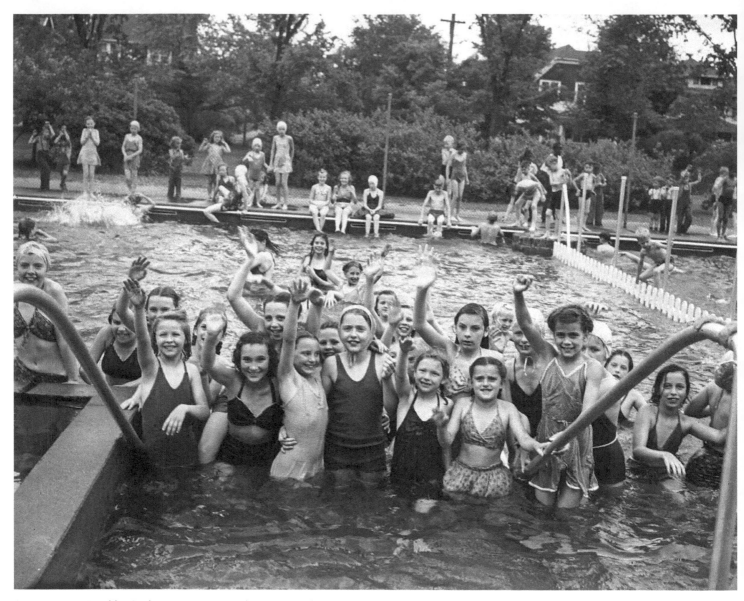

Swimmers at Franklin Park, now Martin Luther King Park, enjoy a cool dip. The city acquired the land in 1911.

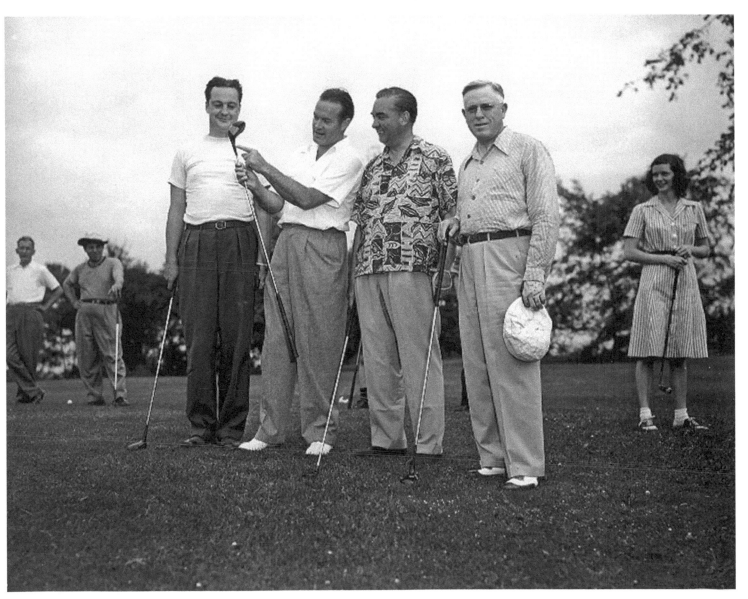

Bob Hope and friends examine Hope's golf club during an outing at Blythfield Country Club.

Several times during the summer, Club Co-ed members met at the Y.M.C.A. for a Saturday night filled with activities. Offered were swimming, dancing to an orchestra, or participating in a variety of games. Harold Fortier is shown here coaxing Shirley Tweddale and Kay Romine into the pool.

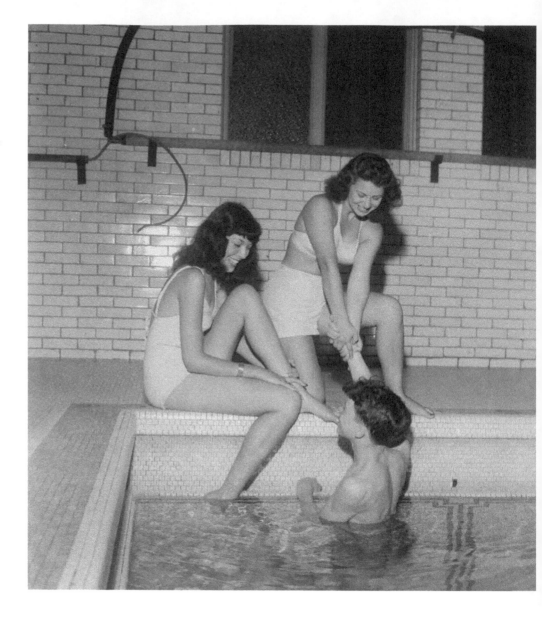

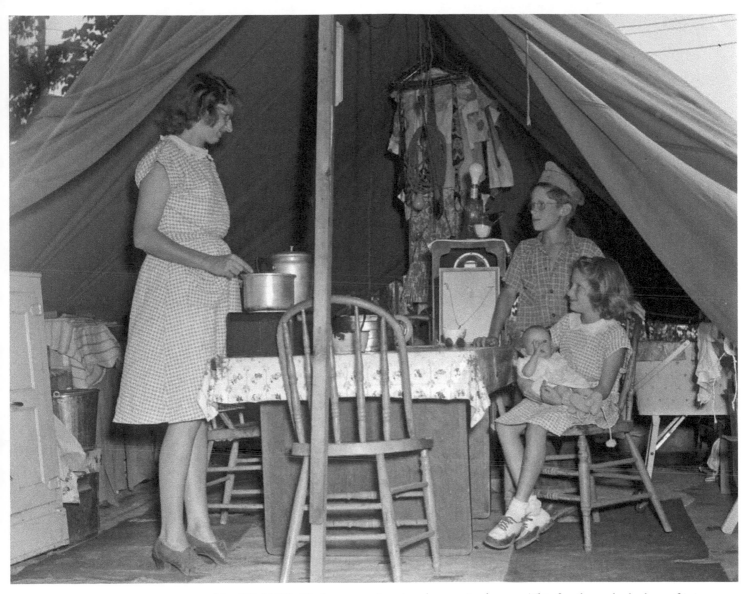

After World War II, there was a housing shortage in the area. This family made the best of it in a tent at the Garden Trailer Coach Park in Cutlerville.

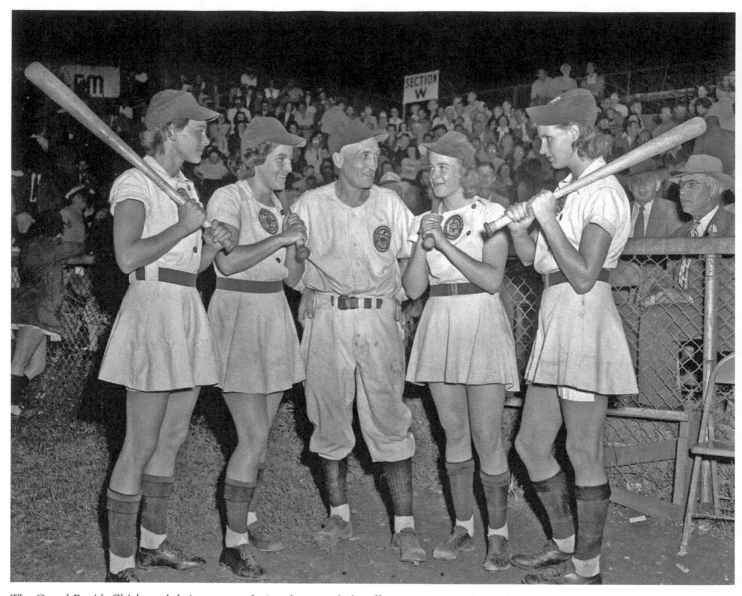

The Grand Rapids Chicks and their manager during the second playoff game versus South Bend.

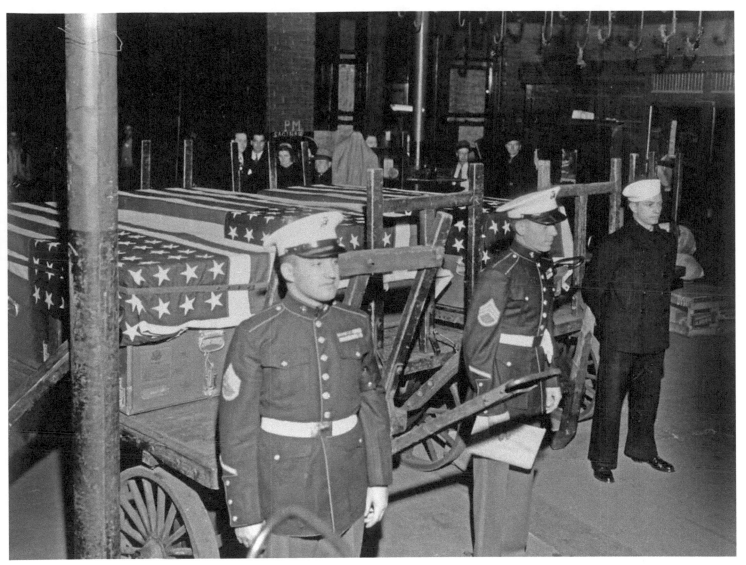

Fallen heroes are quietly returned to their hometowns by the military.

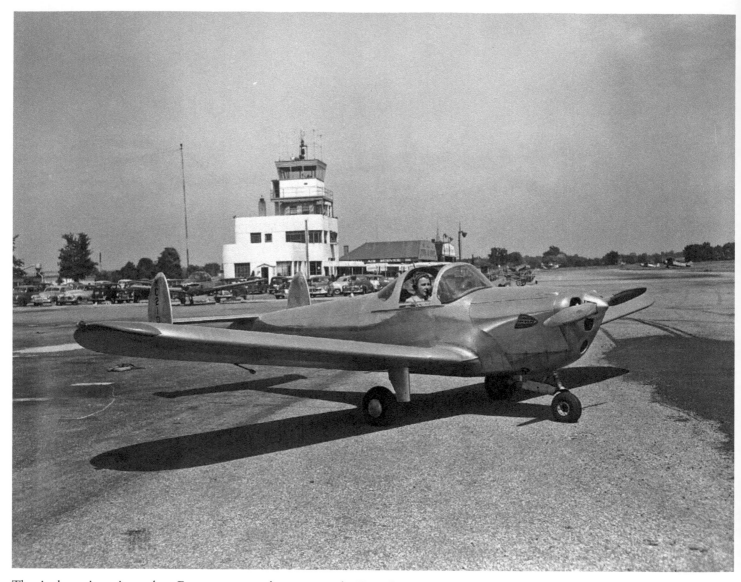

The single-engine private plane Ercoupe rests on the tarmac at the Kent County Airport on Madison Avenue SE, today known as Roger B. Chaffee Boulevard.

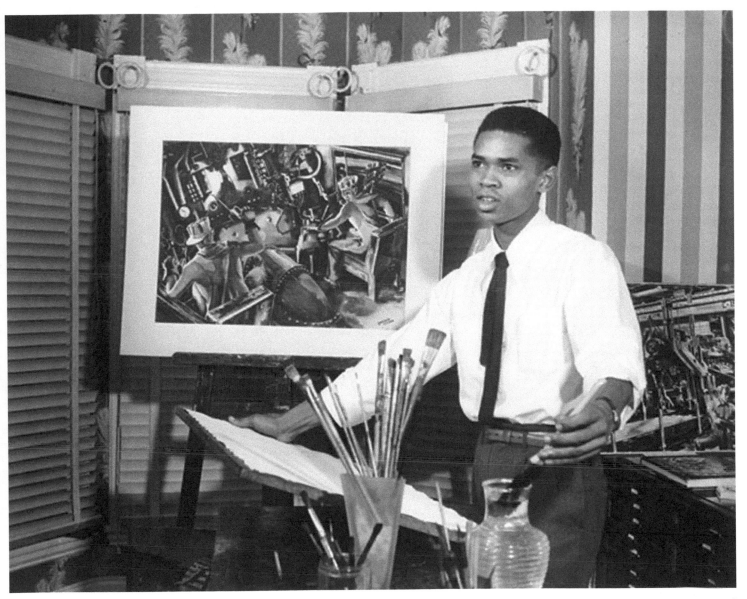

Award-winning Grand Rapids artist William Randolph (Randy) Brown was born in Louisiana and moved to Grand Rapids as a young boy. In 1946, Brown held his first one-man show at the Grand Rapids Art Gallery. He received Honorable Mention in the Grand Rapids National Annual Exhibition of Negro Artists and Sculptors in 1951. Brown likes to paint marine and industrial scenes and landscapes.

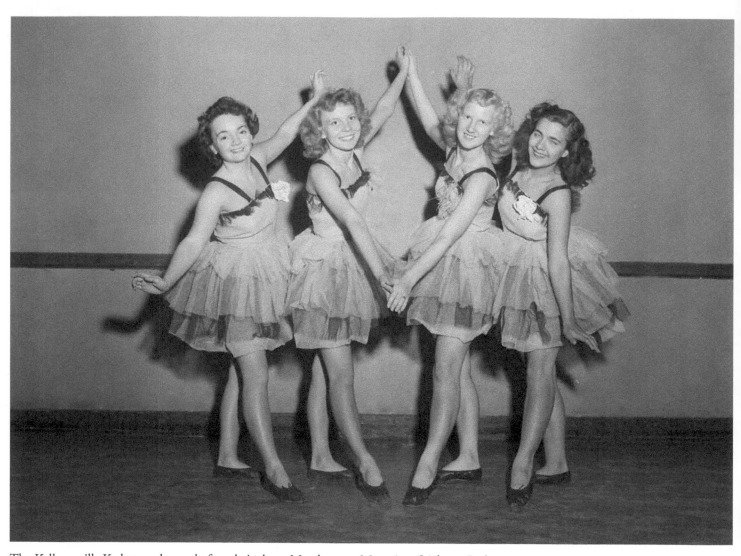

The Kelloggsville Kadettes rehearse before their show. Members are Mary Ann Stickney, Barbara Bronkema, Doris Thayer, and Eleanor Nelson.

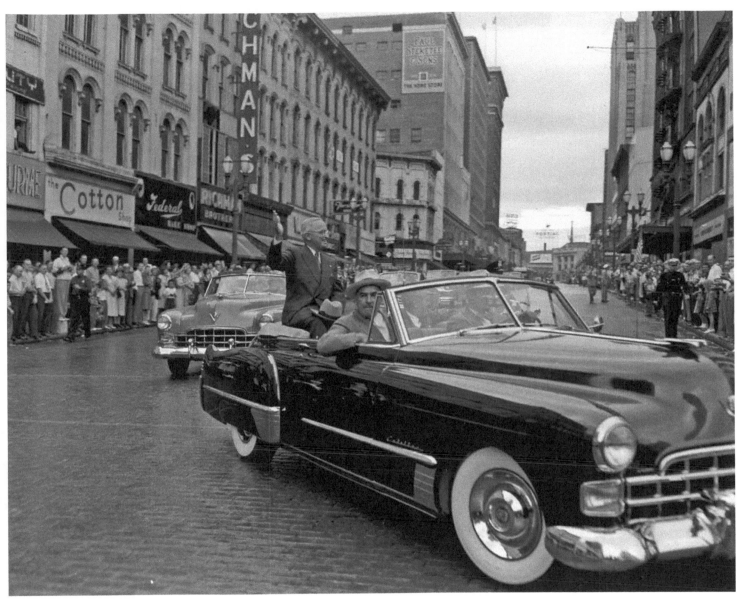

President Harry S. Truman visited Grand Rapids on September 6, 1948. There were approximately 20,000 people in attendance for the parade. Following the parade, Truman gave a brief speech to kick off his reelection campaign.

NOTES ON THE PHOTOGRAPHS

These notes, listed by page number, attempt to include all aspects known of the photographs. Each of the photographs is identified by the page number, a title or description, photographer and collection, archive, and call or box number when applicable. Although every attempt was made to collect all data, in some cases complete data may have been unavailable due to the age and condition of some of the photographs and records.

36 **MAIL CARRIER**
Grand Rapids Public
Library 185-2-36.1646

37 **FIRST CURLING CLUB**
Grand Rapids Public
Library 54-7-26.2485

38 **SODA FOUNTAIN AT WEST'S
DRUG STORE**
Grand Rapids Public
Library 69-1-25.25.922

39 **HORSE-DRAWN FLOAT**
Grand Rapids Public
Library 54-11-13.1

40 **THE COUNTY BUILDING**
Grand Rapids Public
Library 66-1-3.821

41 **BUS LINE**
Grand Rapids Public
Library 54-5-28.10

42 **STREETCARS AND
AUTOMOBILE**
Grand Rapids Public
Library 54-44-21.3030

43 **POLICE DEPARTMENT**
Grand Rapids Public
Library 54-41-15.278

44 **AUSTIN AUTOMOBILE
COMPANY**
Grand Rapids Public
Library 143-2.nn

45 **STREETCAR ON A SNOWY
DAY**
Grand Rapids Public
Library 54-44-21.2512

46 **KILLINGER'S INSTRUMENT
REPAIR SHOP**
Grand Rapids Public
Library 54-17-7

47 **SILVER FOAM BEER**
Grand Rapids Public
Library 54-10-20.2227

48 **WOLVERINE BRASS WORKS
BUILDING**
Grand Rapids Public
Library 54-48-7.39

49 **GRAND RAPIDS AIRPLANE
COMPANY**
Grand Rapids Public
Library 84-21-6.3666

50 **AIRPLANE COMPANY NO. 2**
Grand Rapids Public
Library 84-21-7.1557

52 **THE Y.M.C.A.**
Grand Rapids Public
Library 54-48-14.204

53 **SCHOOL EQUIPMENT
COMPANY BASKETBALL
TEAM**
Grand Rapids Public
Library 54-48-14.4075

54 **ELKS PARADE**
Grand Rapids Public
Library 54-7-47.4

55 **GRAND RAPIDS HERALD
DELIVERY TRUCK**
Grand Rapids Public
Library 54-10-29

56 **AUTOMOBILE VS.
STREETCAR**
Grand Rapids Public
Library 54-44-21.2662

57 **SAINT MARY'S HOSPITAL**
Grand Rapids Public
Library 54-43-12.nn

58 **THE HART PLATE MIRROR
COMPANY**
Grand Rapids Public
Library 54-48-14.4072

59 **LEAGUE OF WOMEN VOTERS**
Grand Rapids Public
Library 141-0-17.4364

60 **ROBERT W. IRWIN
FURNITURE FACTORY**
Grand Rapids Public
Library 84-21-11a.nn

61 **SUPPORTING PROHIBITION**
Grand Rapids Public
Library 101-1-17.2431

62 **POST OFFICE EXPLOSION**
Grand Rapids Public
Library 43-1-4.904

63 **GRAND RAPIDS FIRE
DEPARTMENT**
Grand Rapids Public
Library 43-1-4.185.902

64 **TWO "POLAR BEARS"**
Grand Rapids Public
Library 43-1-1.37.879

65 **VETERANS PARADE**
Grand Rapids Public
Library 54-46-4.18

66 **FORD-STOUT AIRPLANE
MISS GRAND RAPIDS**
Grand Rapids Public
Library 43-1-1.877

67 **GRAND RAPIDS GIRL
SCOUTS**
Grand Rapids Public
Library 43-1-3.135.nn

68 **OFFICER JOHN J.
LEMKE**
Grand Rapids Public
Library 43-2-3.476.3365

69 **MONROE AVENUE AT
DIVISION**
Grand Rapids Public
Library 43-231.387.724

70 **FURNITURE CAPITAL AIR
SERVICE AND KOHLER AIR**
Grand Rapids Public
Library 46.3271

71 **LEONARD STREET
PRODUCE MARKET**
Grand Rapids Public
Library 54-7-4.1423

72 **WINEGAR FURNITURE
STORE**
Grand Rapids Public
Library 43-2-2.413

73 **SECOND CONGREGATIONAL
CHURCH**
Grand Rapids Public
Library 43-2-2.450

74 **INFANT CLINICS**
Grand Rapids Public
Library 141-10-14.nn

75 **CIVIL WAR MONUMENT**
Grand Rapids Public
Library 43-1-6.265.nn

76 **SCRIP WORKERS**
Grand Rapids Public
Library 67-2-10

77 **SCRIP WORKERS NO. 2**
Grand Rapids Public
Library 67-2-11

78 **SCRIP WORKERS NO. 3**
Grand Rapids Public
Library 67-2-12

79 **SCRIP WORKERS NO. 4**
Grand Rapids Public
Library 67-2-13

80 **DEVAUX AUTOMOBILE**
Grand Rapids Public
Library 125-934-2.nn

81 **BLODGETT HOSPITAL**
Grand Rapids Public
Library 125-931.132

82 **UNITED SUBURBAN
RAILWAY BUS LINE**
Grand Rapids Public
Library 54-5-28.13699

83 **SCRIP WORKERS NO. 5**
Grand Rapids Public
Library 67-2-6.2

84 **CONSTRUCTION OF CIVIC
AUDITORIUM**
Grand Rapids Public
Library 67-2-13.1714

85 **STATUE HONORING JOHN
BALL**
Grand Rapids Public
Library 54-15-18

86 **POLICE RADIO ROOM**
Grand Rapids Public
Library 43-2-3

87 **MOVIE PROMOTION**
Grand Rapids Public
Library 125.r35021.4

88 **BOY AND TOY CAR**
Grand Rapids Public
Library 125.r35200

89 **GRAND ARMY OF THE
REPUBLIC CONVENTION**
Grand Rapids Public
Library 54-46-4.16

90 **RAMONA PARK**
Grand Rapids Public
Library 125.c031719.2

91 **VETERAN'S MEMORIAL
PILLARS**
Grand Rapids Public
Library 43-1-6

Printed in the USA
CPSIA information can be obtained
at www.ICGtesting.com
JSHW041645240624
65300JS00026B/762

9 781683 368342